IMAGES
*of America*

# JACKSON

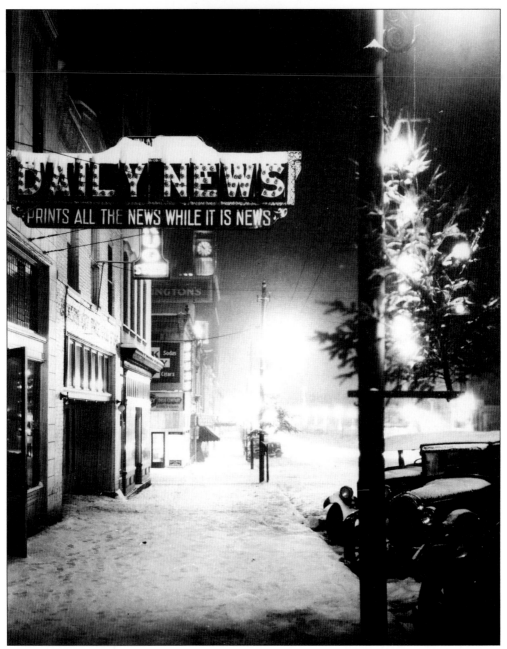

The *Jackson Daily News* began publication in 1860. In 1915 the paper moved its headquarters to 507 East Capitol Street, next to the Kress 5-10-25 Cent Store. The *Daily News* merged with the *Clarion-Ledger* in June 1989. (Photograph courtesy of Mississippi Department of Archives and History.)

IMAGES
*of America*

# JACKSON

Julie L. Kimbrough

ARCADIA
PUBLISHING

First printed 1998
Reprinted 1999, 2002

Published by Arcadia Publishing
Charleston SC, Chicago IL, Portsmouth NH, San Francisco CA

Printed in the United States of America

Library of Congress Catalog Card Number: 98-87704

For all general information contact Arcadia Publishing at:
Telephone 843-853-2070
Fax 843-853-0044
E-mail sales@arcadiapublishing.com
For customer service and orders:
Toll-Free 1-888-313-2665

Visit us on the Internet at www.arcadiapublishing.com

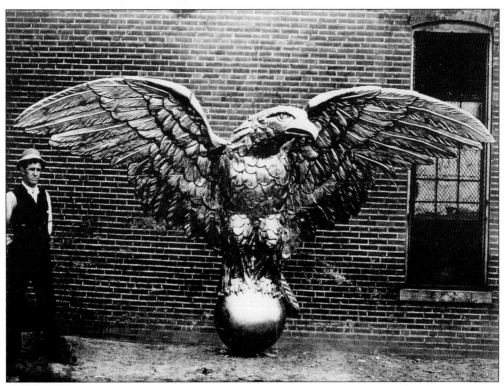

Standing 8 feet tall, the eagle that now graces the top of the New Capitol (1903) dome hovered over its creator, A.R. Grieve. The eagle, sculpted of sheet copper and coated with gold leaf, has a wingspan of 15 feet. (Mississippi Department of Archives and History.)

# CONTENTS

# ACKNOWLEDGMENTS

This project could not have been completed without the generous assistance and encouragement of my parents, Dan Kimbrough and Ina Gray Kimbrough. My mother served as an invaluable researcher; she also talked to many people during the search for photographs and detailed historical information. Additionally, two of my former professors at Millsaps College, Dr. Robert S. McElvaine, Chair of the History Department, and Dr. W. Charles Sallis, Professor of History, edited portions of this book and provided constructive comments and historical information.

I am very grateful to Helene Rotwein for sharing photographs from the LeFleur's Bluff Heritage Foundation collection. I also appreciate the generosity and expert assistance of the following archivists: Elaine Owens, Graphic & Cartographic Records Curator, Mississippi Department of Archives & History, as well as Nancy Bounds and the staff of the archives reading room; Debra McIntosh, College Archivist, Millsaps College; Mattie Sink, Manuscripts Librarian, Special Collections of Mitchell Memorial Library at Mississippi State University; Turry Flucker, Curator/Archivist, Smith Robertson Museum and Cultural Center; Dr. Clarence Hunter, Senior Archivist, Tougaloo College; Sharron Sarthou, Archives and Special Collections of University of Mississippi; Jackson State University; the National Archives (Archives II) in College Park, Maryland; and the Schlesinger Library at Radcliffe College.

Others who graciously contributed photographs and information include Dr. Jeanne M. Middleton, Barbara Beadle Barber, Anita Beadle Scott, and the family of Richard Henry Beadle; Carolyn Rester and Wade Stephenson from the G.V. "Sonny" Montgomery VA Medical Center; Barbara Barrett, Jackson Zoo; John C. Batte III, Batte Furniture; Cora Ross, Jackson Coca-Cola Bottling Company; Zach T. Hederman Sr., Hederman Brothers; Janice C. Jones, Mississippi State University Cooperative Extension Service; Betty Anne Bailey; Mary Jane Hall; B.B. Wolfe; Banks and Louise McDowell; and the late Dr. Jan Hawks, director of Sarah Isom Women's Center, University of Mississippi.

I would also like to acknowledge the assistance of Ruth C. Guyton, Libby Aydelot, Frank Conic, Margaret Ferriss, Beulah Russell, Barbara Bennett Young, Gil Ford Sr., Gib Ford Jr., Ginger Cocke, Lucy Millsaps, Barbara Westerfield, Mary Alice White, Sally Gardner, Art Richardson, Dr. Lee Williams, LePointe Smith, Dr. and Mrs. T.W. Lewis, Dr. Johnnie Marie Whitfield-Smith, Dr. Bill Baker, Ava Burton Gooch, Robert Stockett Sr., and Billy Orr. Finally, special thanks go to Anna Lamkin Broome and her parents, Adam and Lissa Broome.

# INTRODUCTION

"I believe the Jackson of my day was really scaled for children. And then, in its very
confinement to small and intimate size, it suggested the largeness of the
surrounding world—you could see Jackson end and the country begin."
— Eudora Welty, "Jackson: a Neighborhood," *Jackson Landmarks*, 1982.

From its beginnings as a tiny frontier village perched on LeFleur's Bluff overlooking the Pearl
River, Jackson struggled to find an identity. In 1817 Mississippi became the 20th state in the
Union. Four years later, the governor and state legislature surveyed the area around LeFleur's
Bluff and planned for a permanent capital city. Chosen as the capital site due to its central
location in the state and its proximity to a navigable river, the town still failed to flourish
during its early years. Approximately a dozen families lived in this small village in the middle of
the wilderness. Many state officials preferred the first state capital, Natchez; other towns,
including Vicksburg and Clinton, continued to compete for the right to serve as Mississippi's
capital.

Peter A. VanDorn based his 1822 manuscript map of Jackson on a checkerboard plan
suggested by Thomas Jefferson. The map included alternate squares for parks and "greens" for
public buildings. The first statehouse, a 30-by-40-foot brick building built in 1822, occupied the
corner of Capitol and President Streets. Andrew Jackson spoke in this building during his first
presidential campaign; he returned to Jackson in 1840 and spoke from the portico of the Old
Capitol. President Jackson was a hero to the citizens of Jackson; he and Thomas Hinds had
negotiated the Treaty of Doak's Stand in 1820. Under the treaty, the Choctaw Indians sold 5
million acres of land in central and west Mississippi, thus making it possible for settlers to move
into the area where the new capital city would be located.

During the 1830s the town's luck began to change. New treaties with Native Americans in
north Mississippi helped to solidify Jackson's place as a centrally located capital. Mississippi's
second capitol building, which opened in time for the 1839 legislative session, symbolized the
town's new direction. The Governor's Mansion and Jackson's City Hall were completed during
the 1840s. Churches also added stability and reflected efforts to turn a rowdy frontier town into
a proper capital. The first six churches in Jackson were organized in the 1830s and 1840s after
the legislature set aside a square from the city's original map. Jackson's earliest churches were
First Methodist, First Presbyterian, St. Andrews Episcopal, First Baptist, St. Peters Catholic,
and First Christian. The chapter entitled "Houses of Worship" documents a small part of the

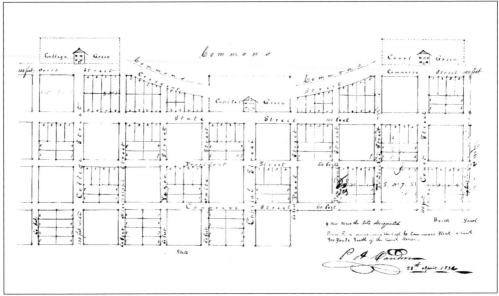

Pictured above is an 1822 VanDorn map. (Mississippi Department of Archives and History.)

history of the town's first churches. Unfortunately, photographs of other important 19th-century churches were impossible to obtain.

Before the Civil War erupted in 1861, Jackson had experienced slow growth as a town in the middle of an agricultural state. Its capacity as the seat of state government was by far its most important role. During the Civil War, Jackson served as a military headquarters and supply center. Union troops occupied Jackson four times, burning war-related businesses, railroads, and other parts of the town. The three most important public buildings in Jackson, the Old Capitol, the Governor's Mansion, and City Hall, survived the Civil War.

At the turn of the century, new railroad lines led to large population gains and steps toward economic growth. Between 1900 and 1910, Jackson's population rose from 7,800 to over 21,000. During the first two decades of the 20th century, Jackson began the transformation from small town to urban center. "For the People" highlights the development of Jackson's public buildings. The 1930s and 1940s were pivotal decades in the city's growth. Jackson's response to the Great Depression and World War II proves the courage of its citizens during hard times. One of President Franklin D. Roosevelt's New Deal programs, the Works Progress Administration (WPA), employed almost 40,000 Mississippians. The WPA became the largest and most popular of the alphabet agencies of the New Deal; it operated from 1935 to 1943.

Today, the metropolitan Jackson area has a population of over 400,000. In spite of its present size, Jackson has retained many of the characteristics of a small town. The first chapter of this book, "Capitol Street," allows the reader to experience the town at street level. Although sections of Capitol Street have declined in the last 30 years, preservation efforts have begun recently. Hopefully, these projects will revive this remarkable piece of the city's history.

Ultimately, this photographic record of Jackson would not exist without the efforts of preservationists, archivists, and historians. "Behind the Camera" features four of the remarkable local photographers who documented the history of the city. Most of the photographs came from the Mississippi Department of Archives and History, the LeFleur's Bluff Heritage Foundation, the National Archives, and the collections of educational institutions including Millsaps College, Mississippi State University, Tougaloo College, the University of Mississippi, and Jackson State University.

# One

# CAPITOL STREET

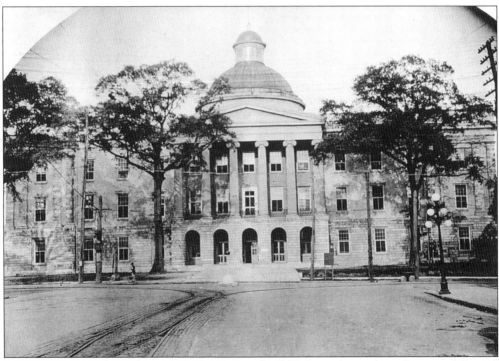

Mississippi's second statehouse, now known as the Old Capitol, stands at the top of Capitol Street. The building served as the state capitol from 1839 to 1903. The capital green, included in the 1822 VanDorn map of Jackson, now houses the war memorial building, the Old Capitol museum, and the state archives. (Photograph courtesy of the National Archives.)

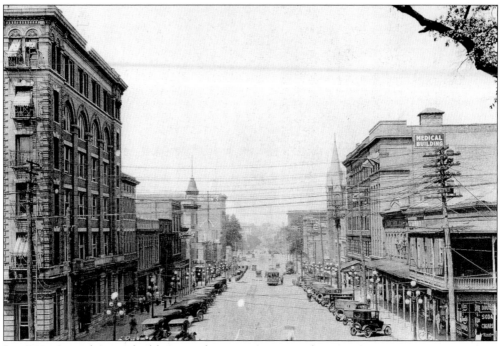

By 1923, Capitol Street had become the city's commercial center. Kennington's Department Store (left background) was one of the first businesses to join the exodus from South State Street to Capitol. On the right side of the street, the steeple of First Baptist Church is visible; this building was demolished in 1926. (LeFleur's Bluff Heritage Foundation.)

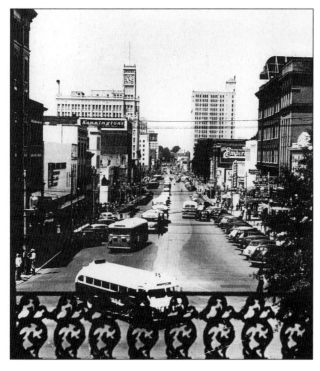

By 1935, buses had replaced electric streetcars as public transportation. Capitol Street also had its first "skyscrapers"—among them the Lamar Life Building and the Merchants Bank (Deposit Guaranty Bank) Building. This 1940s photograph was taken from the portico of the Old Capitol. (Mississippi Department of Archives and History.)

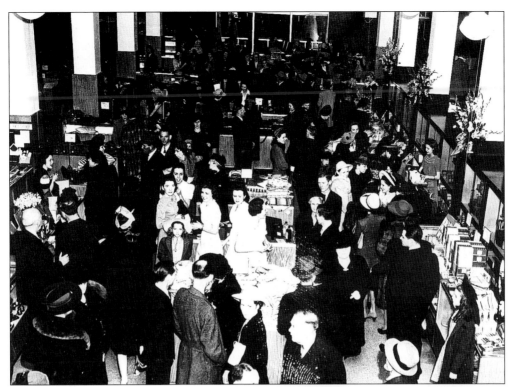

In 1906, Kennington's Department Store moved to 401 East Capitol Street. Owner Robert Estes Kennington introduced fixed-price merchandise and shorter working hours for employees. Later, Kennington's became Jackson's first department store with an elevator and air-conditioning. Kennington's closed in 1970; the building was renamed the Heritage Building and redesigned for office space. (Mississippi Department of Archives and History.)

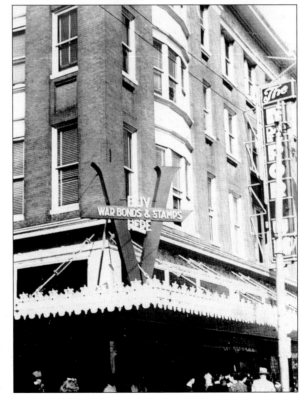

The Emporium, another popular Jackson department store, operated from the 1920s until about 1970 at 400 East Capitol Street. During WW II, the store promoted the Victory war bond campaign. The Emporium Building, restored in 1988, is now on the National Register of Historic Places. (Mississippi Department of Archives and History.)

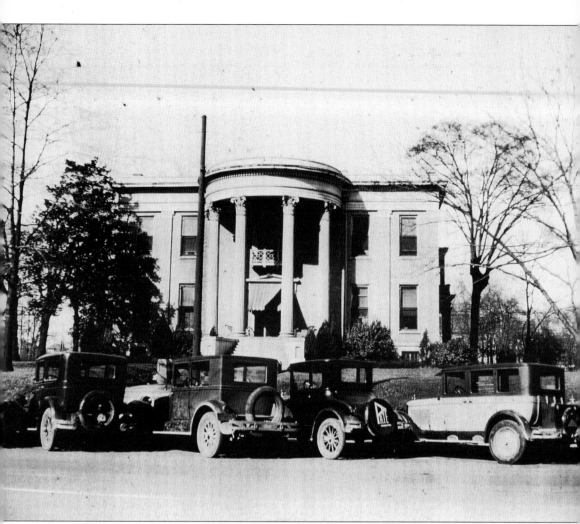

The Mississippi Governor's Mansion, completed in 1841, is the second oldest American residence to house the family of the governor continuously. At the turn of the century, the mansion was in bad shape; the editor of the *Clarion-Ledger* called the house a "dangerous old hulk, a menace to life and property." Under the leadership of Governor Edmund F. Noel and First Lady Alice Noel, the mansion gained an addition as well as extensive renovations in 1908. Governor William Waller and First Lady Carroll Waller guided another significant restoration during the 1970s. (Mississippi Department of Archives and History.)

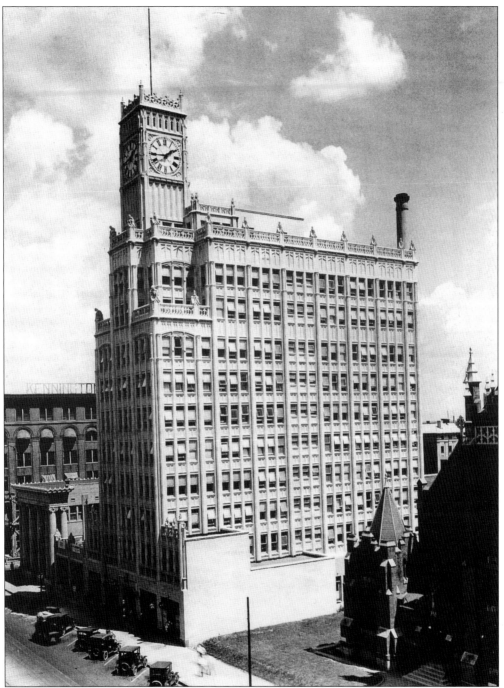

The Lamar Life Building, one of Jackson's early "skyscrapers," opened in 1925. Eudora Welty's father, Christian Welty, was hired by Lamar Life shortly after it was founded; he became secretary of the company and one of its directors. He worked with the architect who designed the 13-story Gothic building. Several stone gargoyles guard the clock tower. Originally, stone alligators flanked the front entrance, but they have been removed. (LeFleur's Bluff Heritage Foundation.)

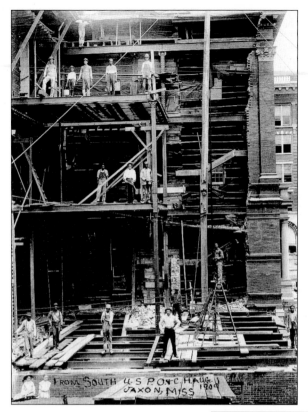

In 1909, the United States Postal Service documented the construction of an addition to Jackson's post office and courthouse. This view shows the unfinished south side of the building on August 1, 1909. Capital National Bank appears at right on the corner of West and Capitol Streets. (National Archives.)

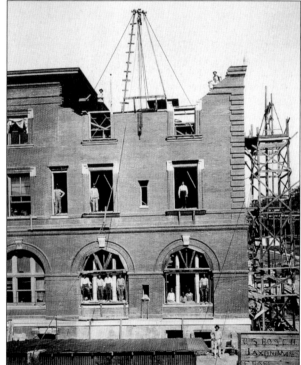

By November 1, 1909, workers had made substantial progress on construction of the post office. The building opened in 1910. Mail from this post office was delivered twice a day throughout Jackson. (National Archives.)

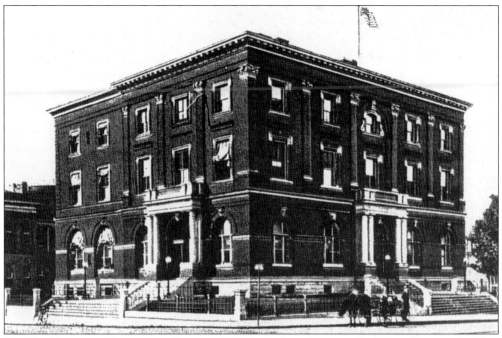

This building served as post office until 1931. Before the next building was completed, a temporary post office occupied space in the garage of the Edwards Hotel. To the far left of the photograph are the Hinds County Courthouse and jail. (Mississippi Department of Archives and History.)

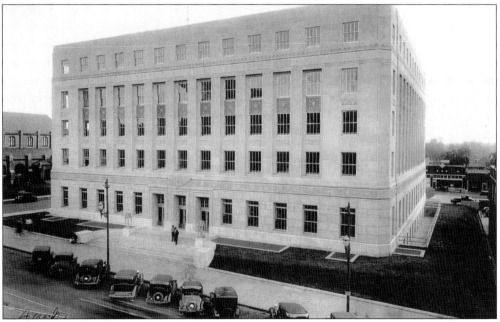

Located on the same site as its predecessor, the next U.S. Post Office in Jackson opened in 1934. The building, designed in the Art Deco style, served as both post office and federal courthouse until 1988, when the main post office moved to its current site. (National Archives.)

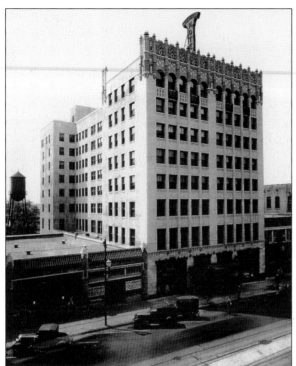

Built in 1928, the Walthall Hotel was named for Edward Cary Walthall, a prominent Jacksonian. Walthall served as district attorney and as a United States senator from 1885 to 1896. The hotel was renovated and reopened in 1991 as the Edison Walthall Hotel. (LeFleur's Bluff Heritage Foundation.)

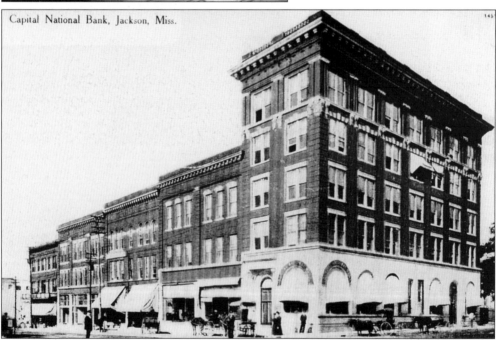

Capital National Bank occupied the northwest corner of Capitol and West Streets; this building served as the bank's headquarters from 1906 until 1954, when it was torn down and replaced by the current bank building. In 1949, Capital National merged with Jackson State National Bank to form First National Bank, now Trustmark. (Mississippi Department of Archives and History.)

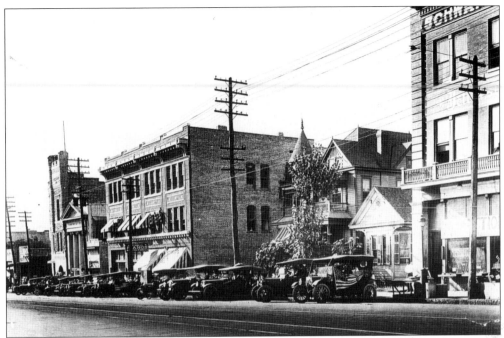

One of the last houses on Capitol Street sat between Albert Frederick Daniel's photography studio (brick building with canopies) and other businesses. By the early 1920s, the 200 block of East Capitol Street was a thriving commercial center. (Mississippi Department of Archives and History.)

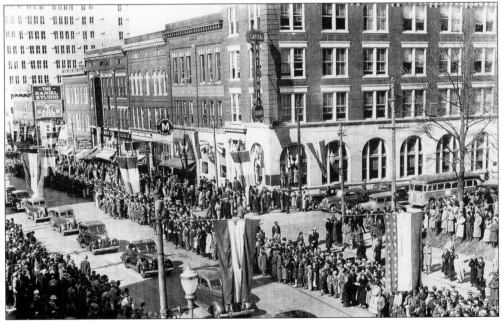

Capitol Street was the city's most popular parade route. This parade probably marked the inauguration of Governor Hugh White in January 1936. Large crowds lined the street to watch the governor and his staff parade to the Governor's Mansion. (LeFleur's Bluff Heritage Foundation.)

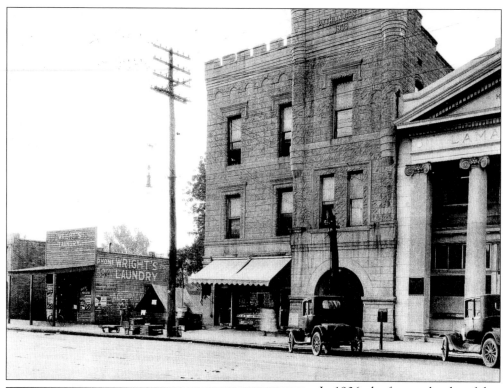

In 1906, the fraternal order of the Knights of Pythias built their meeting hall in the 200 block of East Capitol Street. In 1925, the new Deposit Guaranty National Bank moved into the Lamar Life and Casualty Insurance building. Lamar Life built this two-story structure (right) as its first headquarters in 1906. (LeFleur's Bluff Heritage Foundation.)

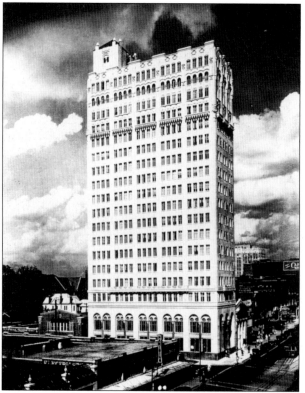

The Pythian Castle was torn down in 1926 to make way for the 18-story Merchants Bank Building. Deposit Guaranty National Bank purchased the building in the 1930s and eventually added the 22-story Deposit Guaranty Plaza behind it. (Mississippi Department of Archives and History.)

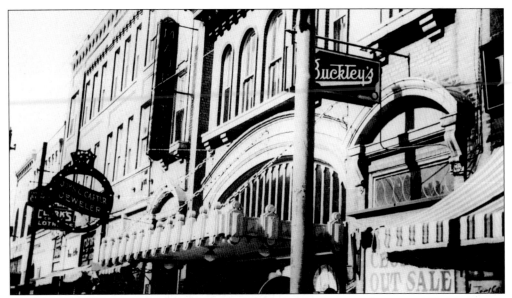

The Majestic Theatre opened in 1914 on Capitol Street, between Lamar and Farish Streets. During its early days, the Majestic charged 5 or 10¢ for silent movies accompanied by the in-house Majestic Orchestra. (Mississippi Department of Archives and History.)

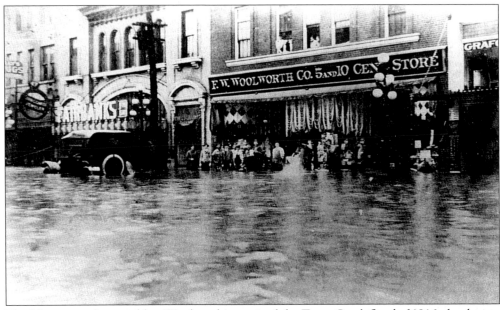

The Majestic and its neighbor Woolworth's survived the Town Creek flood of 1916; the theater displayed "Fairbanks" in lights over its entrance. At flood stage, Town Creek flowed unchecked through Capitol Street in the area between Lamar and Farish Streets. (Mississippi Department of Archives and History.)

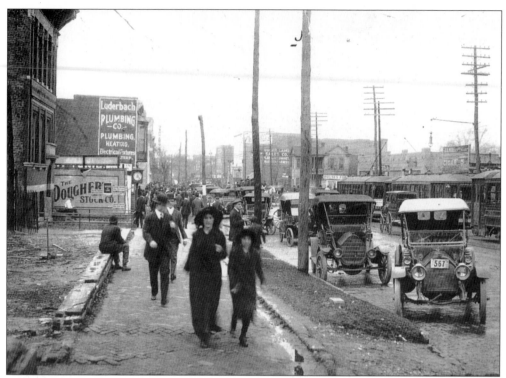

During the Town Creek flood of 1912, Jacksonians gathered on Capitol Street to view the damage. Both men and women dressed in their finest attire for this social occasion. Jackson's electric streetcars appear at right. (LeFleur's Bluff Heritage Foundation.)

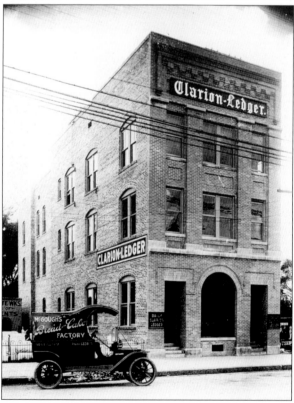

The *Clarion-Ledger* is the city's oldest continuously published daily newspaper. It began daily publication in 1890 and continues today. Its earliest predecessor, the *Eastern Clarion*, was founded in 1837. This building was the newspaper's home during the early 20th century. It was located in the 100 block of West Capitol Street. McGough's Bread and Cake Factory on East Capitol Street sold baked goods from this car. In 1917, McGough's offered a "standard loaf" of bread for 10¢. (Mississippi Department of Archives and History.)

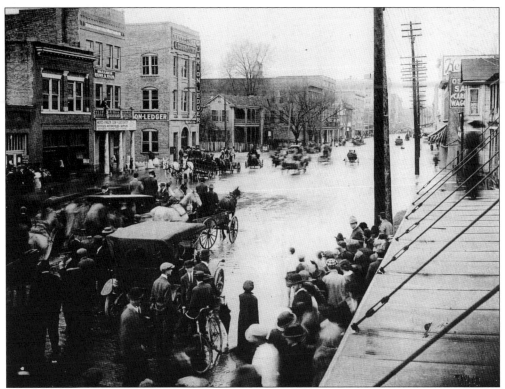

The *Clarion-Ledger* occupied the south side of West Capitol Street in 1914. This photograph looks to the west toward flood waters from Town Creek. Automobiles and pedestrians were stuck until the water receded, but most Jacksonians still relied on their faithful horses and wagons or carriages to take them through high water. (LeFleur's Bluff Heritage Foundation.)

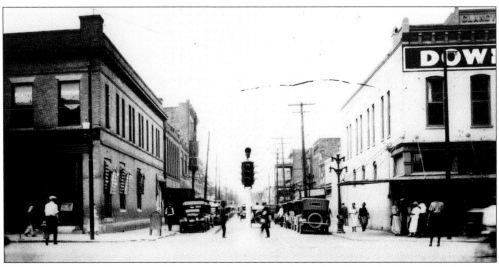

This photograph shows Farish Street at its intersection with Capitol Street. Farish Street Historic District today encompasses 125 acres and contains almost 700 buildings. Boundaries for the historic district are Amite, Fortification, Mill, and Lamar Streets. (LeFleur's Bluff Heritage Foundation.)

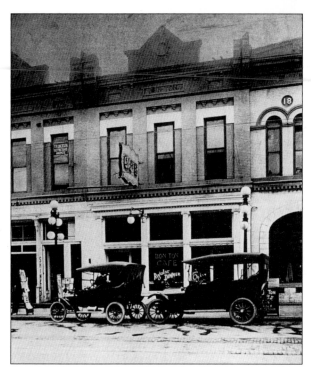

The Bon-Ton Café served Jacksonians for many years at 211 West Capitol Street. Once one of Jackson's finest restaurants, the café had the first electric sign on Capitol Street. In a window to the left of the sign, the T.V. Jackson detective agency advertised its services. (Mississippi Department of Archives and History.)

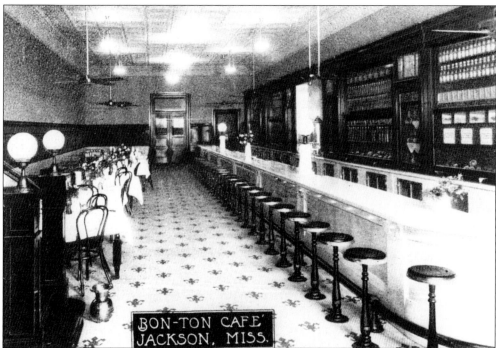

Because the Bon-Ton was within sight of the railroad depot, many WW I servicemen dined there; the restaurant even served some meals on the train platform. In 1909, the Bon-Ton advertised a complete Sunday dinner menu for 35¢. (Mississippi Department of Archives and History.)

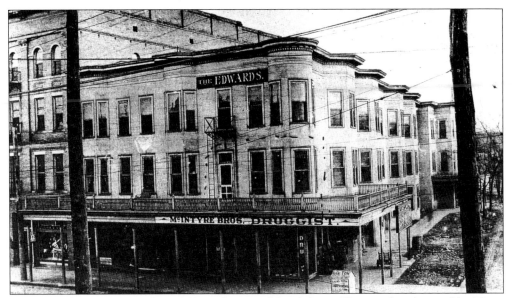

The Edwards House opened in 1868 on the site of Confederate House, a hotel owned by Major R.O. Edwards and burned by Sherman's troops in 1863. The hotel's proximity to the train station caused rooms on one side of the building to be very noisy; the striking rooms with bay windows were the most susceptible to noise. Famous guests at the Edwards House included Charles Lindbergh. (Mississippi Department of Archives and History.)

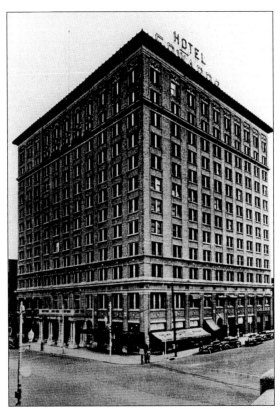

In 1923, Edwards House was demolished and the renamed 12-story Edwards Hotel went up in its place. Calling itself "Mississippi's finest," the hotel offered room rates from $2 a day in 1932. Many state senators and representatives lived there during the legislative session. In fact, one reporter noted "there are three separate branches of the Mississippi Legislature—the Upper House, the Lower House, and the Edwards House." (Mississippi Department of Archives and History.)

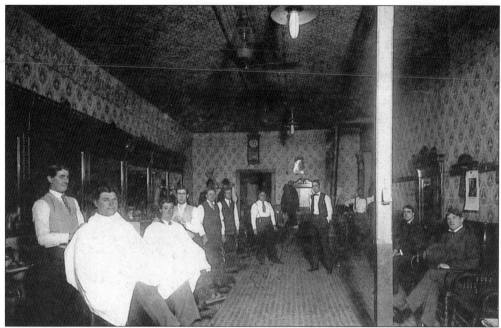

Frank Reed (at the back center of the photo, wearing a tie and suspenders) owned a barber shop on West Capitol Street for over 50 years. Taken around 1894, this photo shows the first location in the 200 block of West Capitol next to the Bourgeois Jewelry Store. Reed later moved his shop to the Edwards House. (Courtesy of Betty Anne Bailey.)

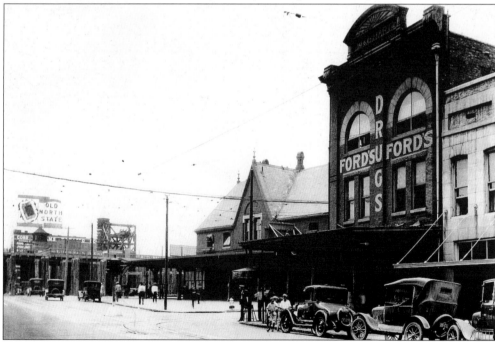

Ford's Drugstore faced McIntyre's Drugstore across Capitol Street and was adjacent to the railroad depot. The competing stores offered prescription drugs and elaborate soda fountains. (LeFleur's Bluff Heritage Foundation.)

24

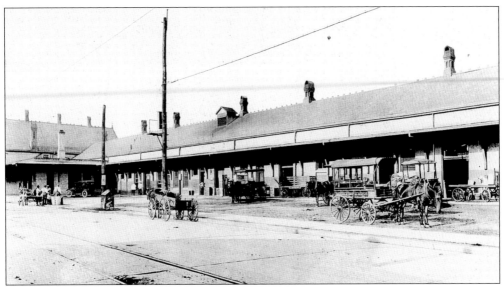

The Illinois Central Railroad station was the busiest place in Jackson for many years. Photographed in 1897, the depot was a gateway for the town's rapid expansion. Even after automobiles entered the transportation scene, the railroad was the preferred choice for out-of-town trips. Most of Mississippi's roads were dirt or gravel until the 1930s. (Mississippi Department of Archives and History.)

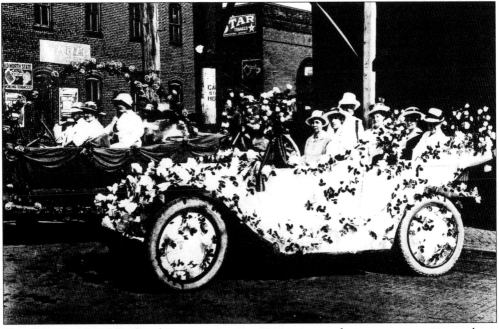

The Illinois Central Railroad Station was not just a center of transportation; it was also a favorite local gathering place. Jacksonians gathered to watch the trains arrive and depart. An indoor miniature golf course operated under the railroad viaduct, across the street from the train station and the Edwards Hotel. The "Heart o' Jackson" golf course had felt greens and offered running ice water. This group of women waited under the elevated tracks for their cue to join a parade up Capitol Street. (LeFleur's Bluff Heritage Foundation.)

25

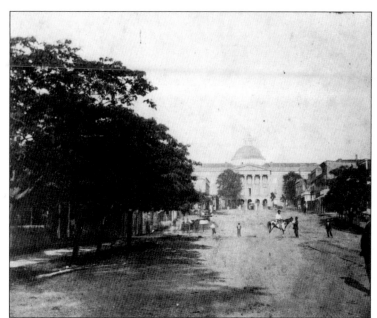

By the 1870s, Capitol Street had begun to expand to the west. However, most businesses remained close to State Street and the Capitol until the turn of the century. The opening of the Illinois Central Railroad Station in the 1880s changed the west end of Capitol Street from a residential area into a thriving business district. (Mississippi Department of Archives and History.)

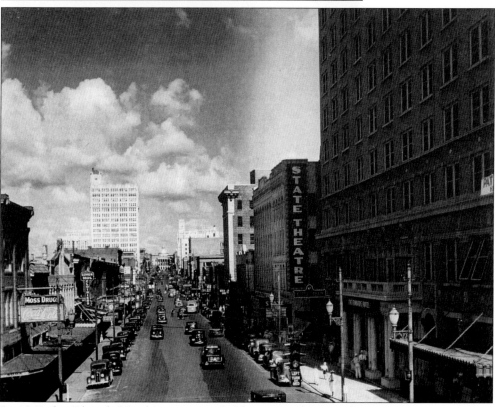

By 1940 the Edwards Hotel was surrounded by movie theaters, drugstores, restaurants, and shops. Senator Pat Harrison had his campaign headquarters in the hotel. During the height of its popularity, Capitol Street was the social, political, and economic center of Jackson. (Mississippi Department of Archives and History.)

# Two

# FAMILIAR FACES

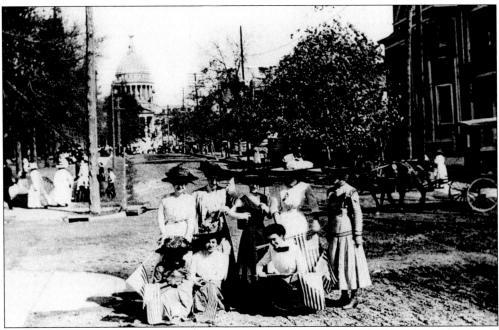

In 1903 Congress Street was unpaved, and the New Capitol building had just been completed. After a political rally, this group of friends posed for a photographer on Congress Street. Smith Park is located on the left side of the street. Pictured from left to right are: (kneeling) Florence Lehman, Beatrix Lehman, and Juliette Lehman; (standing) Carrie Hatry, Aleyne Ascher, Hazel Forshime, Gladys Ascher, and Marie Ascher. (Courtesy of Helene Rotwein.)

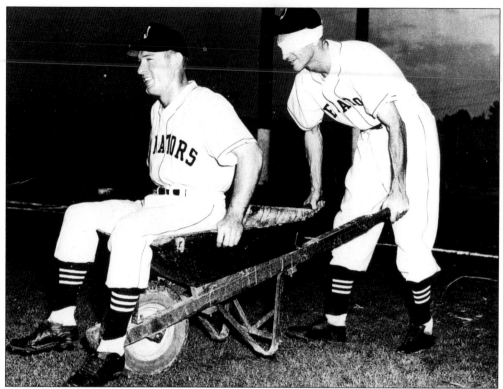

The Jackson Senators, a farm team of the Boston Braves, played in Jackson from the 1920s to 1953. The Senators' field, League Park, was a part of the State Fairgrounds; the Mississippi Coliseum now occupies that site. During a 1948 Fun Night at a Senators game, Tommy Davis, called "Mayor," and Banks McDowell, known as "The Walking Man," entertained the crowd. (Senators photographs courtesy of Banks and Louise McDowell.)

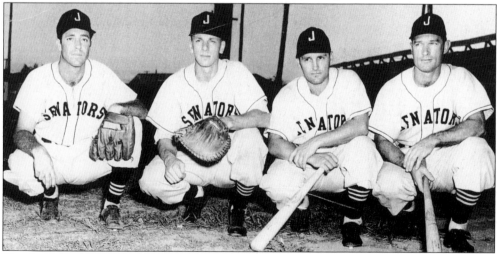

The Senators won the Southeastern League pennant in 1947. In 1948, pitcher Zennie Britt, catcher Walt Linden, second baseman Bill Adair, and center fielder Banks McDowell were named league All-Stars. McDowell drove the team bus part-time; he earned 3¢ a mile. Local author Willie Morris reminisced about the Senators in his book *Good Old Boy*.

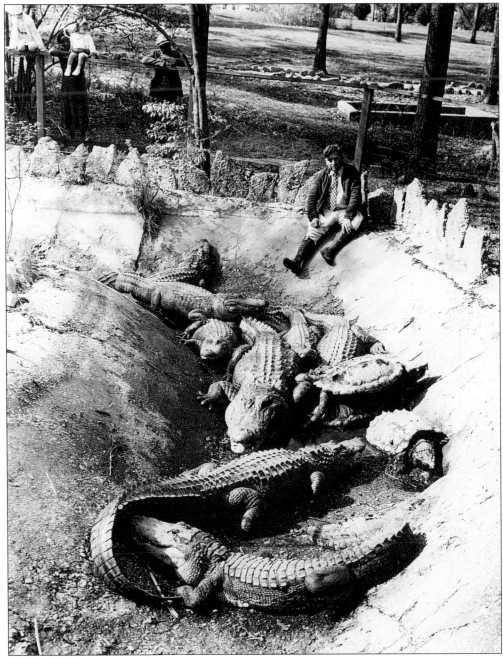

The Jackson Zoo began with animals collected by firefighters at Central Fire Station. Irl Bennett, surrounded by alligators and turtles, served as the zoo's first director. As a young man, Bennett studied dentistry, but he loved animals and left to join Ringling Brothers Circus. Bennett retired as director of the Jackson Zoo in 1964. (Courtesy of Jackson Zoo.)

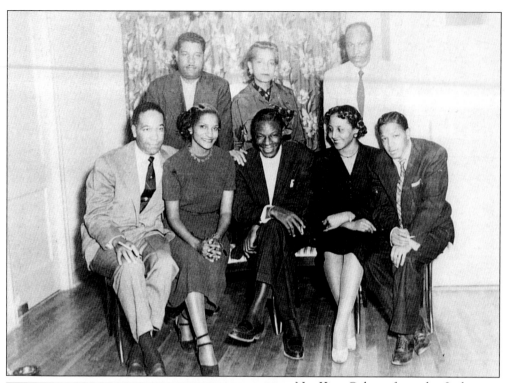

Nat King Cole performed at Jackson State University's College Park Auditorium in the 1950s. Pictured at a social event following the concert, from left to right, are: (front row) Charles Carpenter (manager), Barbara Beadle Barber, Nat King Cole, Mattie Rundles, and Illinois Jacquet (saxophone player); (back row) Arthur Barber, Juanita Davis Beadle, and Jimmy Rundles. (Courtesy of the family of Richard Henry Beadle.)

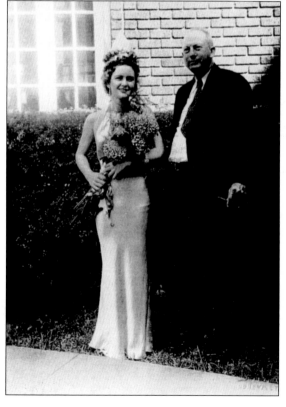

United States Senator Pat Harrison congratulated Rachel Smith after she became Miss Mississippi 1935. Harrison served in the senate for 23 years until his death in June 1941. He served as chairman of the Senate Finance Committee and helped to ensure passage of the Social Security Act. (Mississippi Department of Archives and History.)

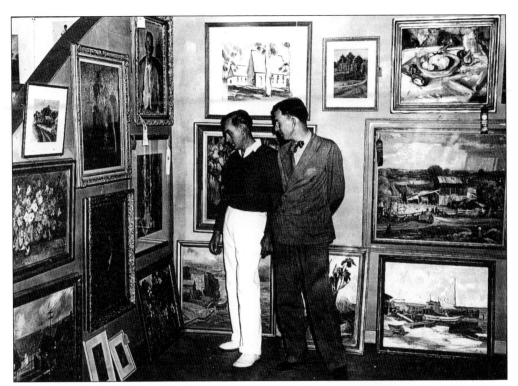

Artists Karl Wolfe (left) and William Hollingsworth judged paintings for a contest at the State Fair during the late 1930s or early 1940s. Wolfe, a native of Brookhaven, Mississippi, studied at the Chicago Institute of Art before returning in 1930 to live in Jackson. At that time he was one of a handful of professional artists in the state. Wolfe taught art at Millsaps College, but his portraits of state officials and famous Mississippians were the foundation of his career. William Hollingsworth was a professional artist who also lived in Jackson. Hollingsworth started the art department at Millsaps and served as its first chairman. (Mississippi Department of Archives and History.)

Mildred Nungester married Karl Wolfe in 1944; she also studied at the Chicago Institute of Art and earned a masters degree from Colorado Springs Fine Arts Center. Karl and Mildred Wolfe built a home and studio on Old Canton Road which was then a dirt road 2 miles north of the end of the North State Street streetcar line. Mildred and her daughter B.B. Wolfe still operate the art studio. (Courtesy of B.B. Wolfe.)

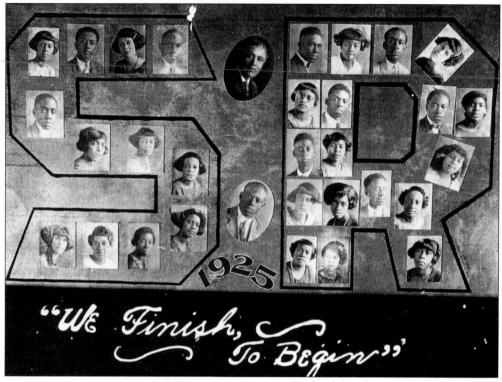

"We Finish, To Begin"

Richard Wright, pictured at the top center of the "R" between two women, graduated from Smith Robertson School in 1925. After moving to Chicago, he joined the Federal Writers Project of the Works Progress Administration (WPA). In 1945, Wright published his autobiography *Black Boy* which included his experiences as a teenager living in Jackson. (Smith Robertson Museum and Cultural Center.)

Dr. Margaret Walker Alexander, poet and novelist, taught at Jackson State University from 1949 to 1979. During the 1930s, Margaret Walker worked on the WPA Federal Writers Project in Chicago; one of her colleagues was Richard Wright. She earned her masters and doctorate degrees from the University of Iowa. Her acclaimed novel, *Jubilee*, was published in 1966. (Smith Robertson Museum and Cultural Center.)

Eudora Welty, renowned author and life-long resident of Jackson, received the Pulitzer Prize for *The Optimist's Daughter* in 1972. Before she published her first story in 1936, Miss Welty worked for the WPA in Mississippi as a photographer. Her first book, A *Curtain of Green*, was published in 1941. (Mississippi Department of Archives and History.)

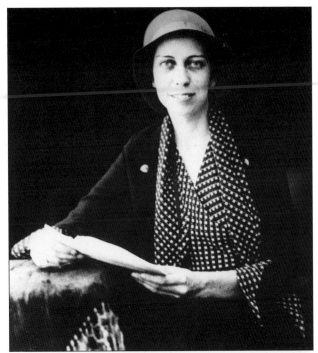

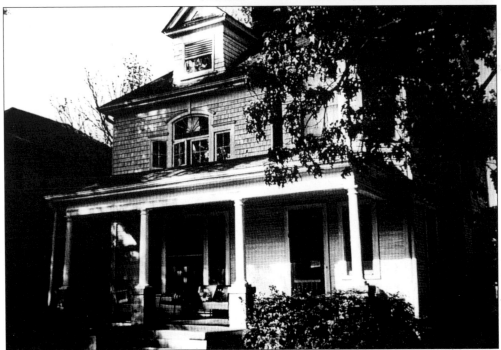

Eudora Welty was born in this house at 741 North Congress Street in 1909. Her father, Christian Welty, built the house for her mother, Chestina Andrews Welty, in 1907–08 when they moved to Jackson after their marriage. Miss Welty attended Davis School on Congress Street. She studied at Mississippi State College for Women before graduating from the University of Wisconsin in 1929. (Mississippi Department of Archives and History.)

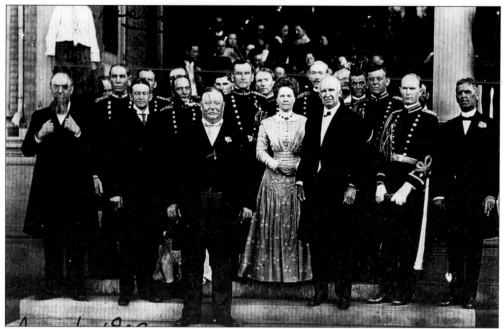

On November 1, 1909, William Howard Taft became the first President of the United States to visit Jackson while in office. Taft stands front and center next to Mrs. Alice Noel and Governor Edmund F. Noel. The *Daily News* described the group gathered to see President Taft as "the largest crowd that ever gathered at one point in Mississippi." (Mississippi Department of Archives and History.)

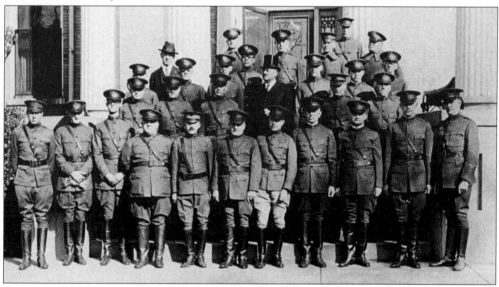

Standing on the steps of the Governor's Mansion, Governor Henry Lewis Whitfield (at center wearing a top hat) is surrounded by his colonels on inauguration day, January 22, 1924. Whitfield's major opponent in the governor's race was Theodore Bilbo. The outcome of the election depended largely on the vote of women. Whitfield studied law at Millsaps College and served as president of Mississippi State College for Women. (Mississippi State University Special Collections.)

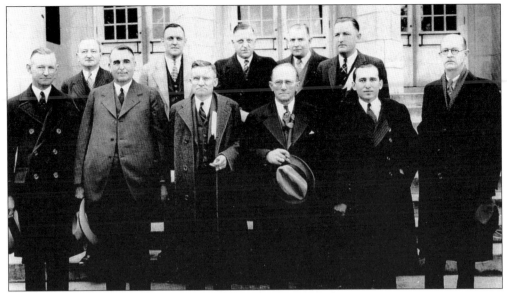

This group of notable Mississippians gathered for the opening ceremony of Livingston Lake in west Jackson. Fred Sullens, *Daily News* editor (second from right on back row) and Theodore G. Bilbo (third from right on front row) had a turbulent relationship. After Bilbo failed to be reelected governor in 1932, Sullens wrote Bilbo's political epitaph: "Beneath this stone old Theo lies/ Nobody laughs and nobody cries/ Where he's gone, or how he fares/ Nobody knows and nobody cares." However Bilbo reappeared and was elected to the U.S. Senate in 1940 and 1946. Sullens's editorial column was named "The Low Down on the Higher Ups." (LeFleur's Bluff Heritage Foundation.)

Governor Fielding Wright (wearing glasses) greeted Governor Strom Thurmond of South Carolina during a 1948 presidential campaign trip. Both men were members of the States' Rights party or Dixiecrats. During the 1948 Democratic National Convention, delegates from the Deep South had walked out because of the civil rights platform of the convention. Thurmond was the unsuccessful presidential candidate of the Dixiecrats in 1948; Wright was the vice-presidential candidate. (Mississippi State University Special Collections.)

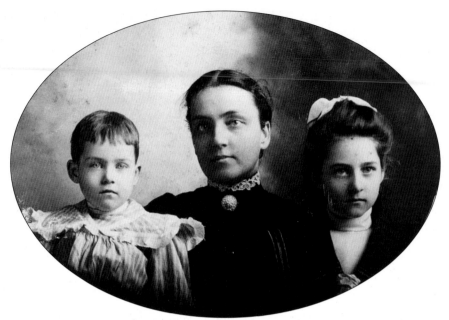

Eleanor Nugent Somerville was the first woman to serve in the Mississippi House of Representatives; she was elected in 1923. Women were granted the right to vote in 1920 by the 19th amendment to the Constitution. Nellie Somerville also served as president of the Mississippi Woman Suffrage Association. She is pictured with her daughters Eleanor and Lucy. (Schlesinger Library, Radcliffe College.)

Lucy Somerville Howorth followed her mother into politics. After graduating from the University of Mississippi School of Law, Lucy married Joseph Howorth. The couple practiced law in Jackson, and in 1931 Lucy was elected to the House from Hinds County. This is her legislative portrait. Lucy Howorth later recalled her husband's role in her campaign. She said that her husband bought a new Panama hat before the campaign. By election day, the hat had a hole in the brim from all the times he had gallantly tipped it to ladies. (Schlesinger Library, Radcliffe College.)

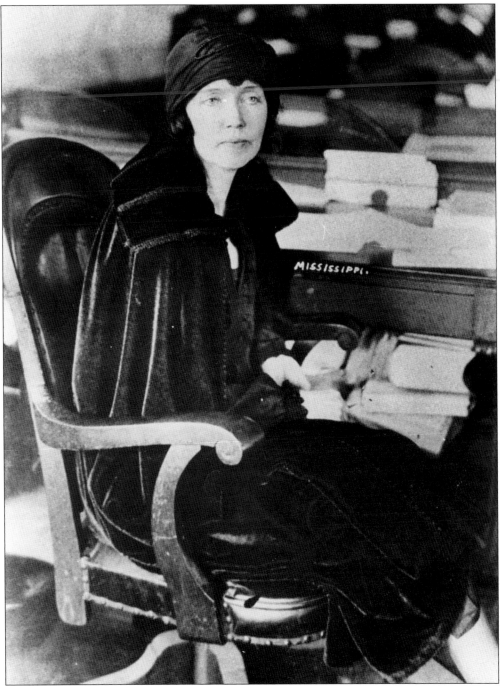

In 1925, Ellen Sullivan Woodward became the third woman elected to the Mississippi legislature. After the death of her husband, Albert Woodward, she was elected to finish his term in the state house of representatives. This position marked the beginning of Woodward's political involvement. From 1933 to 1938, she served as director of women's work relief for three different New Deal agencies. Woodward was the second most powerful woman appointed by President Franklin D. Roosevelt. (Mississippi Department of Archives and History.)

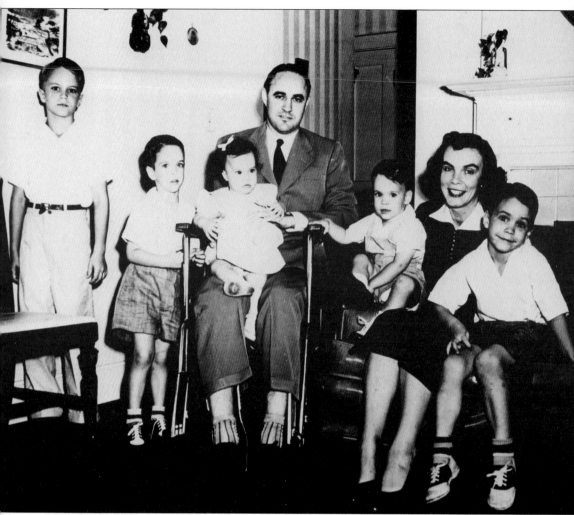

Dr. Arthur C. Guyton served as head of the Department of Physiology and Biophysics at the University of Mississippi Medical Center for 34 years, from 1955 to 1989. His world-famous *Textbook of Medical Physiology* has entered its ninth edition and is published in many different languages. Guyton also invented the motorized wheelchair after his own battle with polio. Arthur Guyton and his wife Ruth, a Phi Beta Kappa graduate of Wellesley College, had ten children; all ten became medical doctors. The children pictured with their parents in 1952 are David, John, Catherine, Steven, and Robert. Children not pictured are Jean, Douglas, James, Thomas, and Gregory. (Department of Archives and Special Collections, University of Mississippi.)

# *Three*

# FOR THE PEOPLE

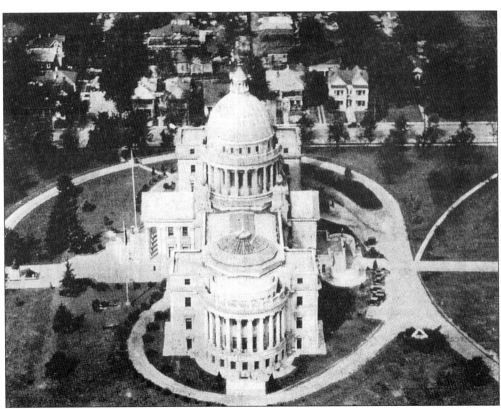

Completed in 1903, Mississippi's third statehouse is the current seat of state government. Known as the "New Capitol," the building imitates many architectural aspects of the United States Capitol. The New Capitol cost about $1 million, but construction was funded primarily through back taxes owed to the state by several railroad companies. (Mississippi Department of Archives and History.)

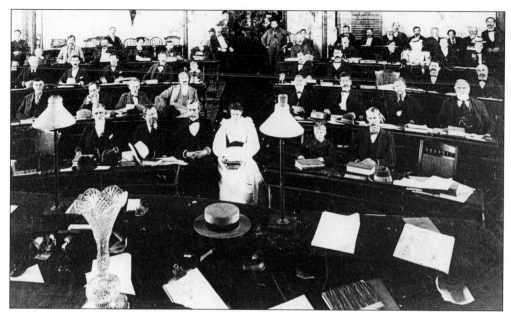

The Mississippi House of Representatives met in this chamber of the Old Capitol until 1903. In 1839 legislators met here to pass the first Married Women's Property Act in the nation; this law gave married women the right to keep title to property they had held before marriage. By the late 1890s, when this photograph was taken, the Old Capitol building was already in danger of collapsing. Inspectors warned that the entire building had begun to lean to the southwest and that the rotunda tilted 6 inches in the same direction. (Mississippi State University Special Collections.)

For many years, state officials dumped old books and state records on the third floor of the Old Capitol. The excessive weight began to contribute to the building's structural problems. In 1896, J.L. Power, secretary of state, had tons of the documents burned and ordered the rest thrown out the windows into wagons for temporary storage at the penitentiary. This photograph, c. 1930, shows the Old Capitol during its tenure as a state office building; the interior was completely reconstructed in 1917. (Mississippi Department of Archives and History.)

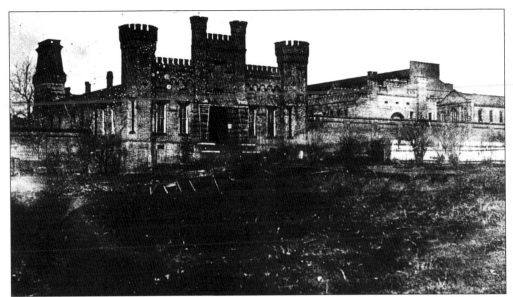

The first state penitentiary opened in 1840 at the northern boundary of Jackson. The prison was one of five manufacturing enterprises in the city from 1857 to 1881. Union troops burned the prison in 1863, but the state rebuilt it on the same site. By the turn of the century, the city had grown around the prison, and many Jacksonians demanded its removal. (Mississippi Department of Archives and History.)

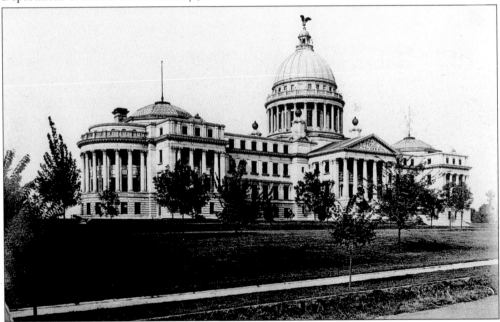

In 1901, state officials answered the citizens' demands by tearing down the penitentiary, removing prisoners to state prison farms, and beginning construction of the much-anticipated New Capitol building. The building is an example of the Beaux Arts style and contains marble and stained glass from around the world. All three branches of state government were housed in the New Capitol until the judicial branch moved in 1972 to the Carroll Gartin Justice Building. (LeFleur's Bluff Heritage Foundation.)

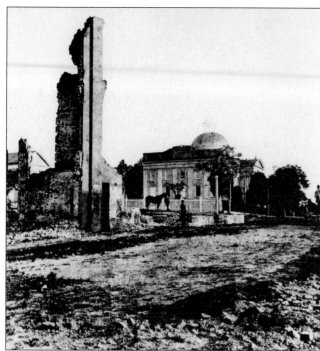

The Bowman Hotel, located across Amite Street from the Old Capitol, burned accidentally in 1863. The Bowman had been Jackson's largest and most popular hotel. The shell of the building remained until 1875, when the remaining bricks were sold. Legislators often gathered at the hotel, and Generals Grant and Sherman planned military strategy there. (Mississippi Department of Archives and History.)

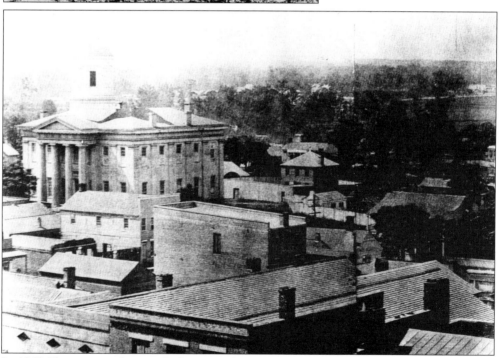

In 1869 Elisaeus von Seutter, Jackson's earliest professional photographer, took a panorama photograph of the town of Jackson. Von Seutter stood on the roof of the Old Capitol to get this view, one of the earliest remaining photographs of Jackson. This panel, one of nine, showcases city hall, which opened in 1847. The domed cupola on top of the building was removed in 1874. (LeFleur's Bluff Heritage Foundation.)

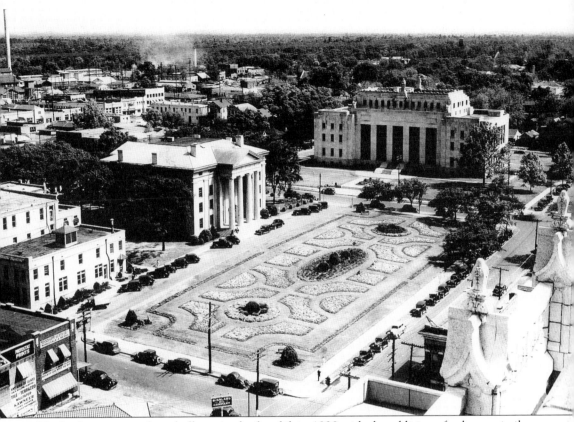

The back entrance of city hall received a face lift in 1928 with the addition of columns similar to those on the front side of the building. The new portico faced the garden plaza. The building served as a hospital for both sides during the Civil War and was not burned by Union troops. Behind the garden is the present Hinds County Courthouse, built in 1930. (LeFleur's Bluff Heritage Foundation.)

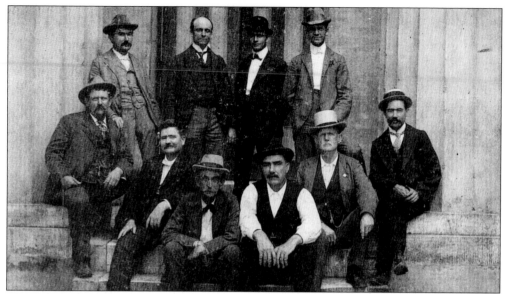

This photograph of "courthouse officials" was taken on the east steps of city hall in 1901. Ed Fondren (front row, far left in front of column) worked for Hinds County for over 50 years and served as circuit clerk from 1905 to 1940. Ed Fondren's brother David opened a grocery store in 1893 and became postmaster of an area known as Asylum Heights. Later named Fondren, this area near the state insane asylum was eventually incorporated into the city. University of Mississippi Medical Center now stands on the site where the asylum was formerly located. (LeFleur's Bluff Heritage Foundation.)

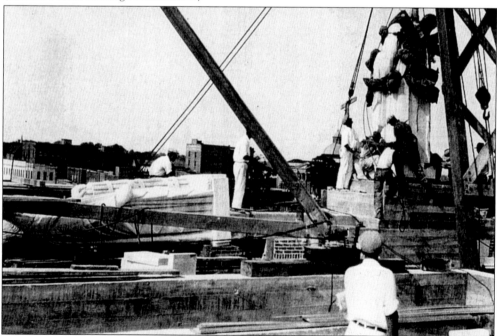

Workers mounted statues on the roof of the new Hinds County Courthouse. The statue of Moses, the giver of law, faces the front of the building while Socrates, the interpreter of law, faces south. The statues are 13 feet high. (Mississippi Department of Archives and History.)

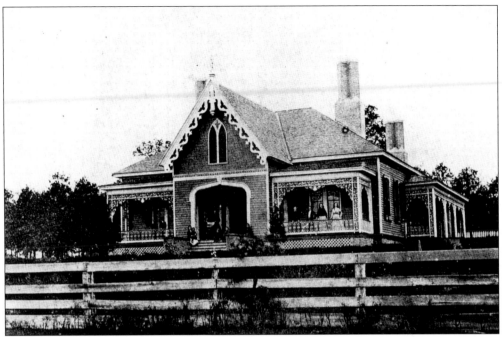

Manship House, built in 1857, is a rare example of Gothic Revival residential architecture in Jackson. Charles Henry Manship served as alderman, postmaster, and mayor of Jackson; Manship, his wife, and ten children lived in the house throughout the Civil War. In his capacity as mayor, Manship surrendered Jackson to General Sherman on July 16, 1863. Located at 420 E. Fortification Street, Manship House has been restored and is open to the public. (Mississippi Department of Archives and History.)

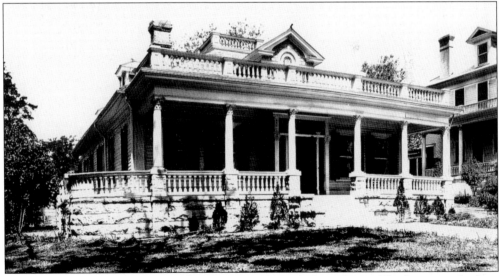

The Municipal Art Gallery opened in 1927 at 839 North State Street. The house was built in 1870 by the Ligon family. A relative built an identical house on an adjacent lot, but that house was later demolished. William Hollingsworth, a local artist, sold enough of his watercolor paintings through the gallery to become a professional artist. (LeFleur's Bluff Heritage Foundation.)

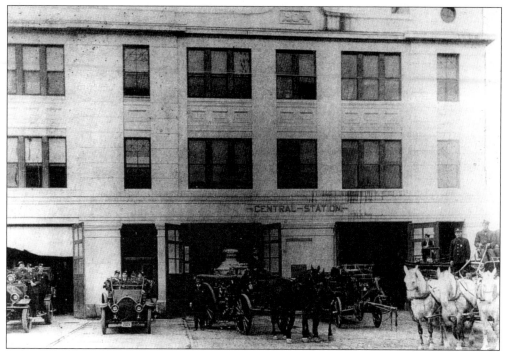

Until 1904, Jackson had only volunteer fire companies. Central Fire Station opened that year at Pearl and President Streets and housed the first paid fire department. The company continued to use horse-drawn equipment, but by 1912 had begun to include automobiles. Firefighters in this station kept animals in cages as pets. In 1919, this menagerie moved to Livingston Park and became the first residents of the Jackson Zoo. (LeFleur's Bluff Heritage Foundation.)

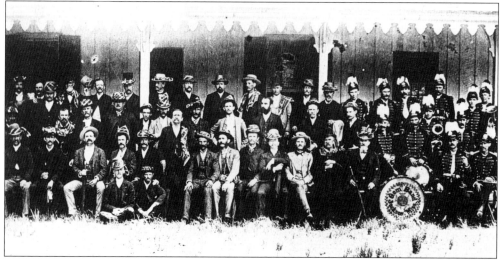

During the late 1800s, the popular Gem Fire Department band furnished musical entertainment for many of the town's social occasions. Volunteer firefighters provided one of Jackson's favorite sources of entertainment. Firemen held monthly competitions to see which company could put the highest stream of water on the Old Capitol dome. (Mississippi Department of Archives and History.)

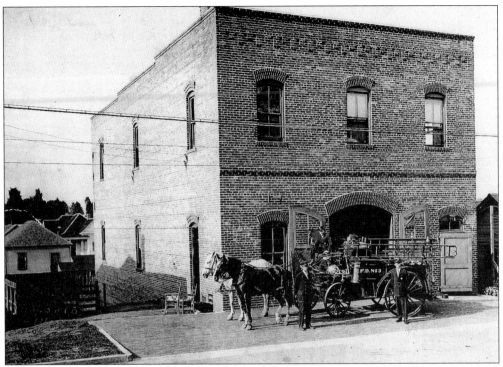

The newly organized city fire department bought the equipment of volunteer companies throughout Jackson and opened new stations. This 1912 photograph of fire station #3 on Fortification Street near North West Street shows one of the last hook and ladder wagons. (LeFleur's Bluff Heritage Foundation.)

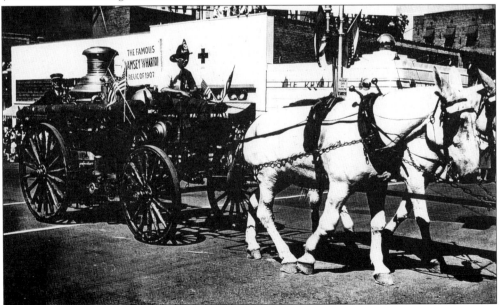

This parade showcased another turn of the century firefighting tool known as "the steamer." The wagon held a large bell in front and a brass boiler in back; a pair of matching white horses usually pulled the steamer. (Mississippi Department of Archives and History.)

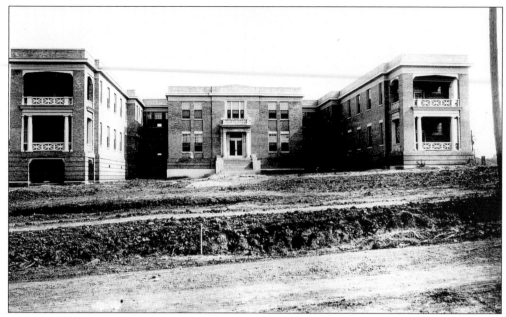

The State Charity Hospital opened in 1912 at the corner of Manship and North State Streets; the facility had three stories and 100 beds. The hospital closed in 1955 after the completion of the University of Mississippi Medical Center, and the property was sold to Mississippi Baptist Hospital. (Mississippi Department of Archives and History.)

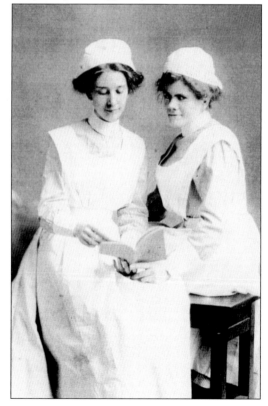

Charity Hospital opened a training school for nurses in 1912. Two nurses who worked at the hospital were photographed in 1915. (Mississippi Department of Archives and History.)

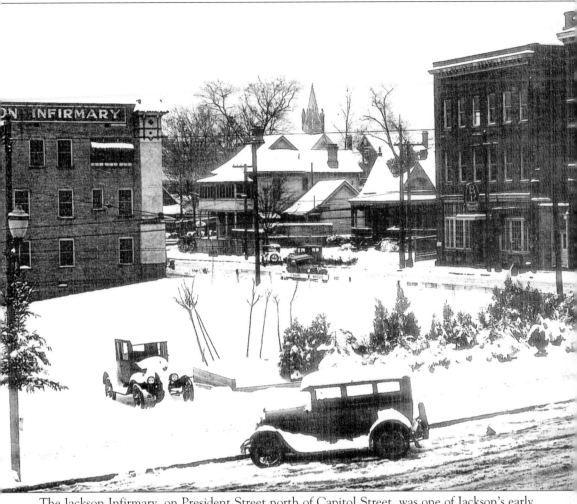

The Jackson Infirmary, on President Street north of Capitol Street, was one of Jackson's early hospitals. The vacant lot formerly occupied by First Baptist Church is in the foreground of this 1924 picture. The infirmary building was later used as the first St. Dominic's Hospital. (Mississippi Department of Archives and History.)

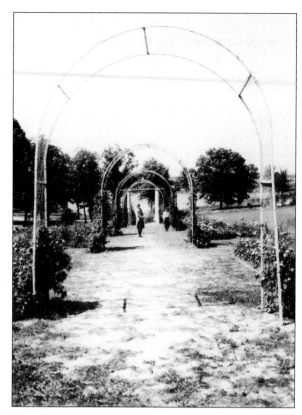

The 1929 rose arbor at Livingston Park stood between the lake and the entrance for the Jackson Zoo; it could be seen from the street. The arbor was surrounded by rose bushes and climbing roses; it was torn down. (LeFleur's Bluff Heritage Foundation.)

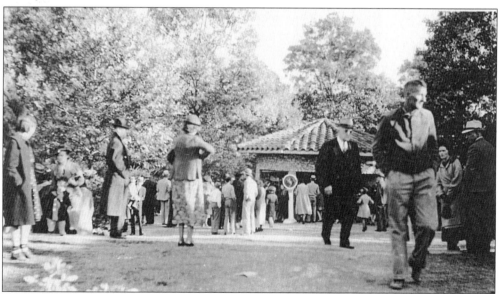

In November 1937, the refreshment stand at the Jackson Zoo drew a crowd. The refreshment stand has been in continuous use for over 60 years and was renovated recently. In the 1930s, the Jitney Jungle grocery store on West Capitol Street provided day-old bread and other food to keep the zoo animals alive. Slaughterhouses gave leftovers to the zoo during WW II. (Jackson Zoo.)

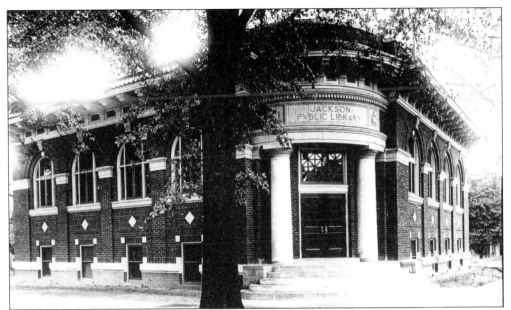

In 1914, Jackson's first public library opened at Congress and Mississippi Streets. The Carnegie Library, partially funded by an Andrew Carnegie endowment, served the city until 1954. The Methodist Building occupies the site of the old library. (Mississippi Department of Archives and History.)

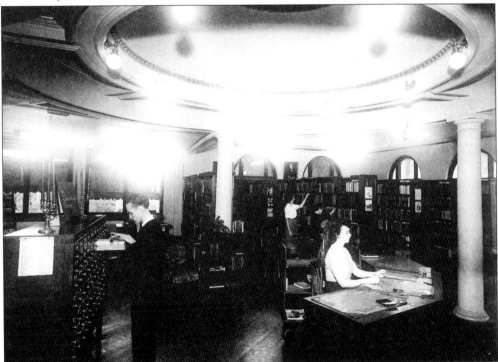

Carnegie Library's reading room attracted a generation of young readers, including Eudora Welty. Today the main branch of the Jackson Public Library, named for Miss Welty, houses a collection of works by Mississippi writers. (LeFleur's Bluff Heritage Foundation.)

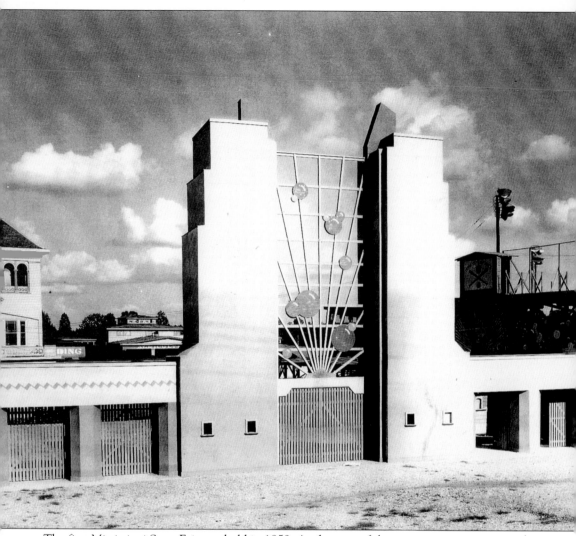

The first Mississippi State Fair was held in 1859. At the turn of the century, gates set up on the lawn of the Old Capitol served as the fairgrounds entrance. Visitors to the fair walked around the capitol and down the back steps which led to the fairgrounds. This fairgrounds entrance gate faced Jefferson Street; it was torn down in 1950. The state fair commission decided in 1951 to add 5 to 15 feet of soil throughout the fairgrounds for flood prevention. League Park, home of the Jackson Senators, is on the right side of the photograph. (LeFleur's Bluff Heritage Foundation.)

# *Four*
# HOUSES OF WORSHIP

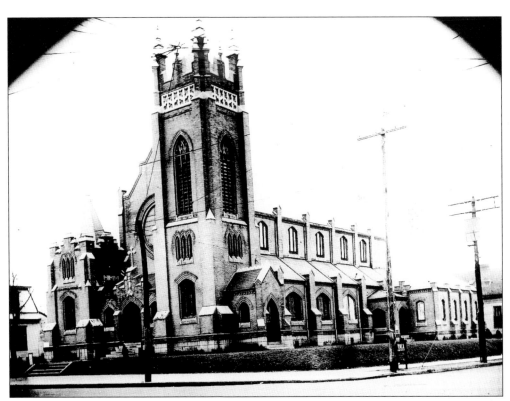

St. Andrews Episcopal Cathedral stands at the corner of Capitol and West Streets. The church's third building opened in 1903, but St. Andrews began as a mission station in 1839 and had only eight communicants. The first church burned during the Civil War, and the congregation outgrew the second building after only 20 years. The present building caught on fire in 1930 during a baptismal service conducted by the rector, Dr. Walter B. Capers. Most of the church was spared, but parts of the roof were redesigned. (Mississippi Department of Archives and History.)

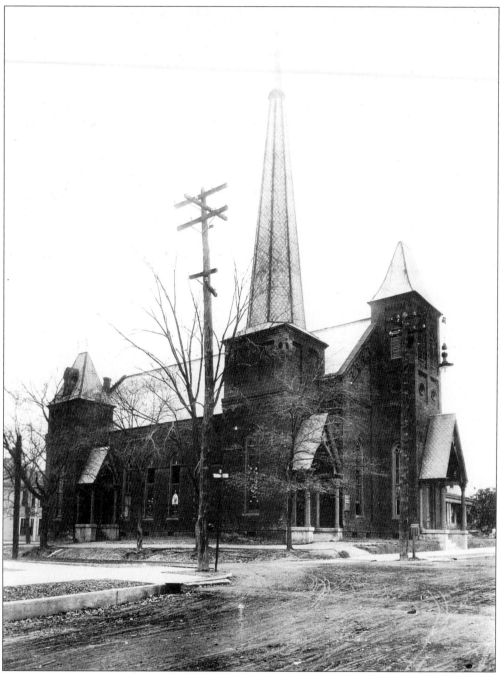

Methodists organized Jackson's earliest church in 1836; services were held in Mississippi's first statehouse. First Methodist Church opened Jackson's first church building on the corner of Yazoo and Congress Streets in 1839. The second church, shown here, opened on the same site in 1883. (Mississippi Department of Archives and History.)

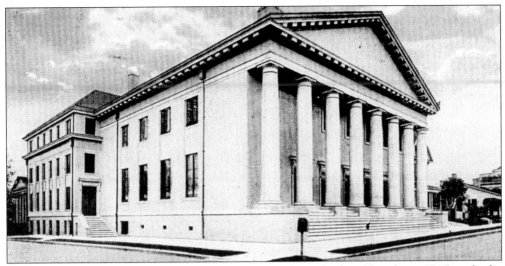

First Methodist Church became Galloway Memorial Methodist Church in 1915 with the completion of its third building. Named for Bishop Charles Betts Galloway, the church continues to occupy the lot that Methodists bought for $50 in 1838. Galloway currently owns the original First Baptist Church building, which was completed in 1844 and is the oldest existing church building in Jackson. (Millsaps College Archives.)

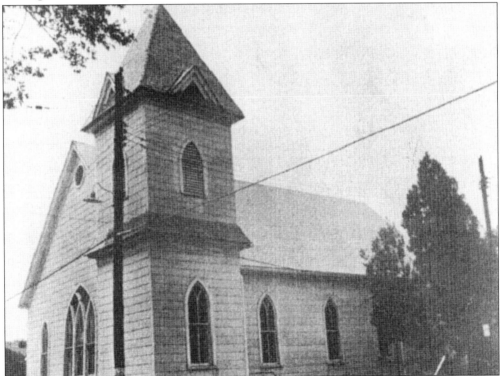

Organized in the basement of First Baptist Church, Mount Helm Baptist Church opened its first building at Church and Grayson Streets after the Civil War. Jackson College, formerly located in Natchez, held classes in this church during the mid-1880s. (Jackson State University Archives.)

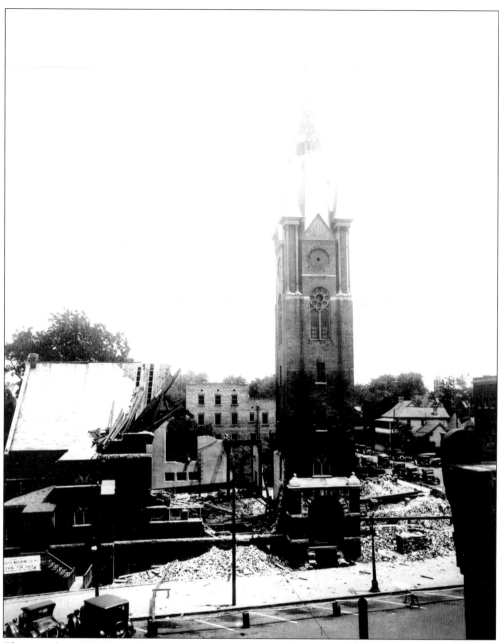

The steeple stood alone after the initial demolition of First Baptist Church's second building; the church worshiped at the corner of Capitol and President Streets from 1894 to 1926. First Baptist bought the land from Dr. William Short, rector of St. Andrews Episcopal Church, who had used it as a cow pasture. During its early years, the church baptized new members in the Pearl River. The original First Baptist Church building opened in 1844 behind First Methodist Church. (Mississippi Department of Archives and History.)

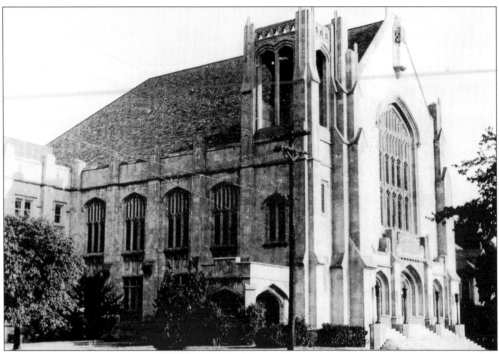

The present First Baptist Church building opened in 1927 and has grown to occupy a complete block from North State to President and College to Mississippi Streets. Local architect N.W. Overstreet worked with Gabriel Ferrand of St. Louis to design the neo-gothic structure. First Baptist Church now has over 9,000 members. (Mississippi Department of Archives and History.)

In 1882 Bishop Charles Betts Galloway formed a small afternoon Sunday school class that met on the second floor of the West Jackson fire station. Capitol Street Methodist Church was organized in 1887 with the appointment of its first pastor. The church's second building opened in 1912 at 531 West Capitol Street; Capitol Street Methodist closed in 1996. (Mississippi Department of Archives and History.)

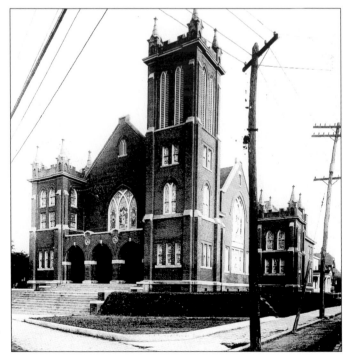

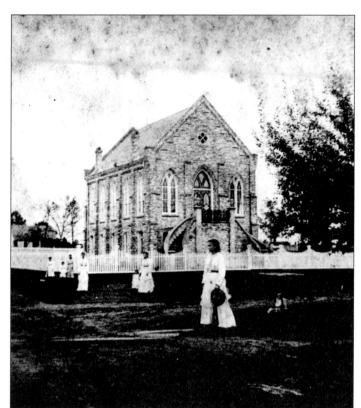

The first Temple Beth Israel opened on South State Street in the late 1860s, but it burned in 1874. The Beth Israel congregation had begun to hold services in 1861. The second building, shown here, stood at the corner of South State Street and South Street until 1940. This stereograph by E. von Seutter could have been taken on June 25, 1875, the temple's dedication day. (Mississippi Department of Archives and History.)

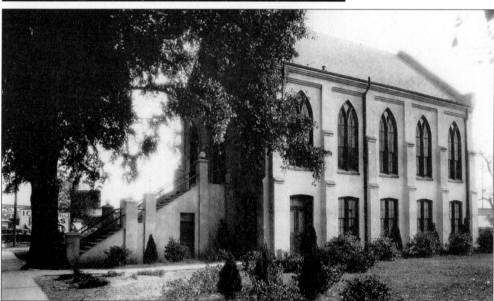

This view shows the second synagogue approximately 50 years later. This building seated 300 people and had solid walnut pews. The congregation of Beth Israel worshiped at Galloway Methodist until the completion of their new synagogue on Woodrow Wilson, behind the Federated Clubs building. The present temple's address is 5315 Old Canton Road in northeast Jackson. (LeFleur's Bluff Heritage Foundation.)

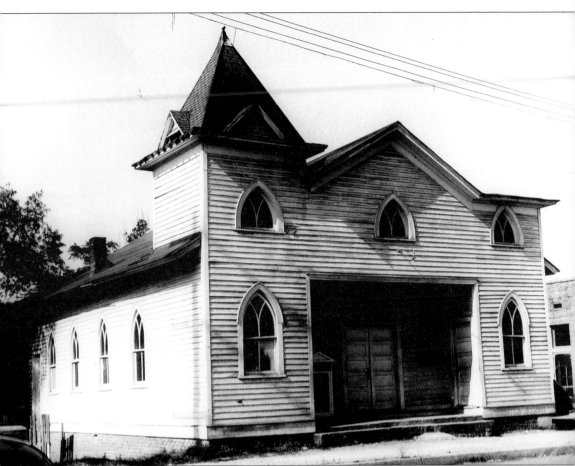

Pearlie Grove Missionary Baptist Church was organized in 1870 by members of Mount Helm Baptist Church. The church remained on South Farish Street until 1975 when it moved to 1110 Grand Avenue. Thurgood Marshall spoke at the church in the 1950s. (Mississippi Department of Archives and History.)

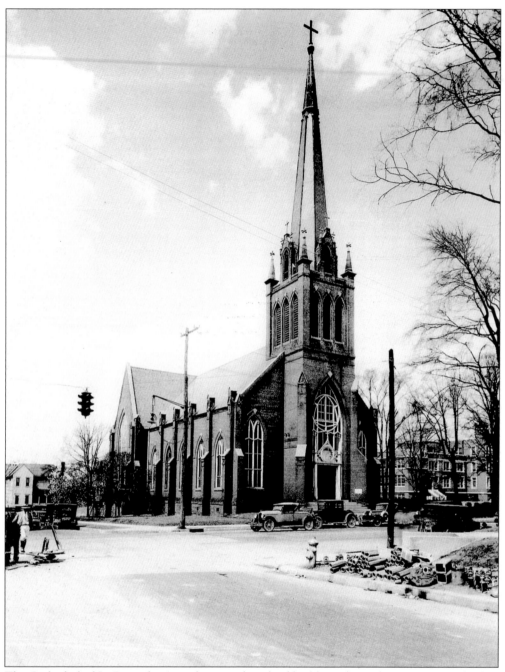

The Cathedral of St. Peter the Apostle opened its third building, shown here, in 1900. The first St. Peter's church opened in 1846 and burned during the Civil War. St. Peter's Rectory now occupies the site of the second church, which was built in 1868. Some townspeople criticized the location, West Street at the intersection of Amite Street, because Town Creek often overflowed the site. (LeFleur's Bluff Heritage Foundation.)

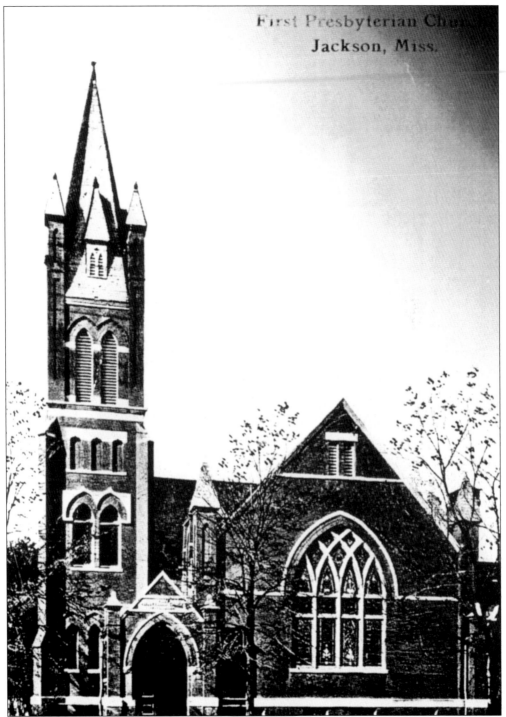

First Presbyterian Church
Jackson, Miss.

Organized in 1837, First Presbyterian Church was located at Yazoo and North State Streets until 1951. This photograph shows the second building on that site. At their present location, 1390 North State Street, the church operates an elementary school. (Mississippi Department of Archives and History.)

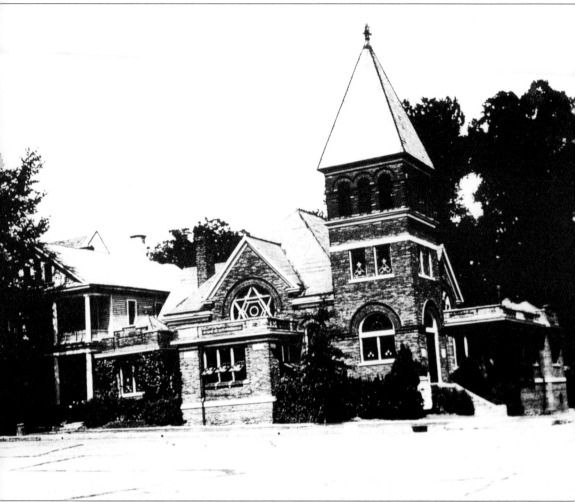

First Christian Church opened its third building in 1891, at the corner of Mississippi Street and President Street, the current site of the First Baptist Church chapel. Organized before the Civil War, First Christian remained at this location until 1950. The present church is located at the corner of High and North State Streets. (Mississippi Department of Archives and History.)

*Five*

# THE NEW DEAL

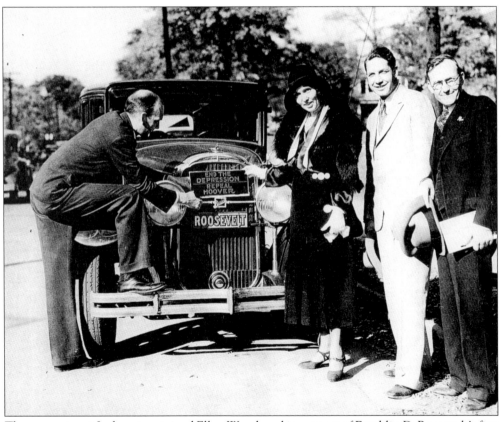

Three prominent Jacksonians joined Ellen Woodward in support of Franklin D. Roosevelt's first presidential campaign. In 1932, Roosevelt easily defeated Herbert Hoover, gaining almost 58 percent of the popular vote. The men are Orin Swayze, Louis Jiggitts, and Carl Howorth. Jiggitts and Woodward were Mississippi members of the Democratic National Committee. (Mississippi Department of Archives and History.)

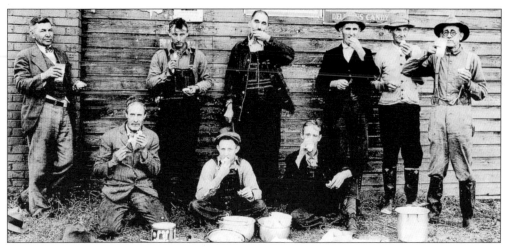

WPA road, or "pick and shovel," projects employed the largest numbers of workers and received the most funding. These men helped with repairs on the Road of Remembrance in west Jackson. Women who lived on this street provided lunch for the project workers. (LeFleur's Bluff Heritage Foundation.)

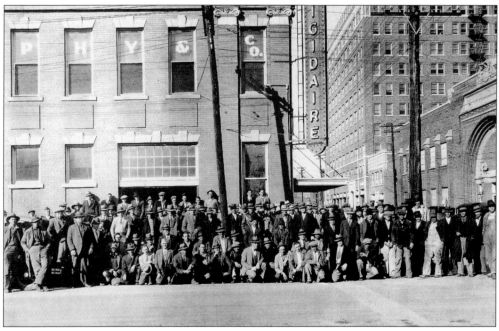

This group of unemployed men from the Jackson area labored on local work projects. During the Depression, Jackson city officials attempted to pass the "One Cent Plan," a 1¢ tax designed to supplement federal funds for work relief; the tax was not approved. The tall building on the right side of the photograph is the Lampton Building, which is now the Electric Building. (LeFleur's Bluff Heritage Foundation.)

The Civil Works Administration (CWA) was one of several relief programs established by Roosevelt during his first year in office. The CWA lasted only a few months, from the winter of 1933 to May 1934, but provided jobs for 4 million Americans during that period. CWA funded repairs and provided workers to renovate the women's building on the Mississippi state fairgrounds; this landmark was torn down around 1950. (LeFleur's Bluff Heritage Foundation.)

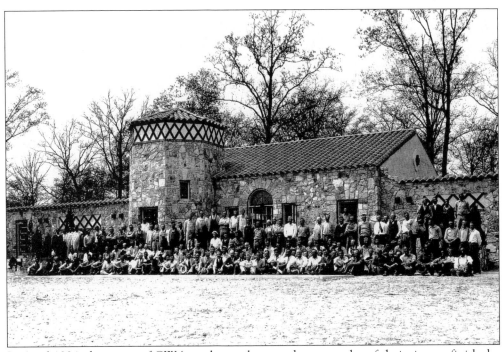

In April 1934, this group of CWA workers volunteered an extra day of their time to finish the bathhouse at Livingston Lake. The 9-acre lake was constructed around 1920 and remained a favorite swimming area until the 1950s. (LeFleur's Bluff Heritage Foundation.)

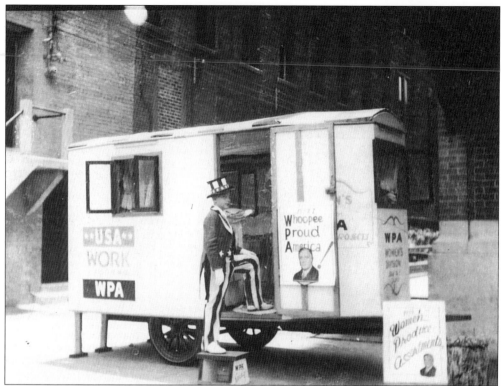

This 1939 publicity photo reflects the efforts of the WPA and other New Deal relief agencies to generate a favorable public image. The WPA was one of the largest and most effective New Deal agencies. (Mississippi Department of Archives and History.)

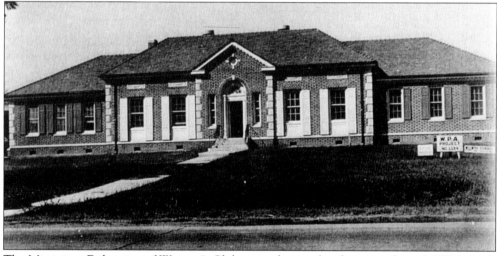

The Mississippi Federation of Women's Clubs gained a new headquarters through WPA funds and labor. Completed in 1936, the building stands at the northwest corner of North State Street and Woodrow Wilson. A large magnolia tree now dominates the front lawn of the club headquarters. The city wanted to cut down the tree in 1942 to accommodate the widening of State Street. The Federation's president, Mrs. H.H. Ellis, staged a protest from the branches of the tree, and the city relented. (National Archives.)

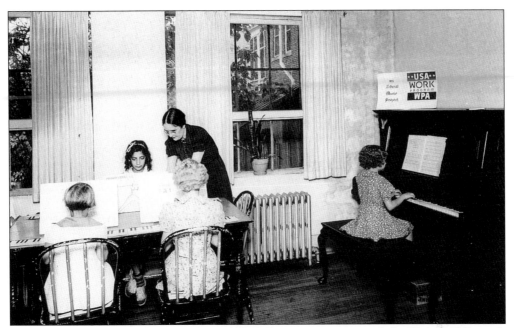

Federal One, a division of the WPA, included four arts programs and the Historical Records Survey. The Federal Music Project encouraged children's involvement in the arts by providing free classes. This piano class met at the YWCA building on North State Street. One child could play the piano while others practiced on paper keyboards. (National Archives.)

The sewing project was the largest WPA program for Mississippi women. This little girl and her doll visited a Hinds County sewing room. Projects included quilts, mattresses, and clothing. (Mississippi Department of Archives and History.)

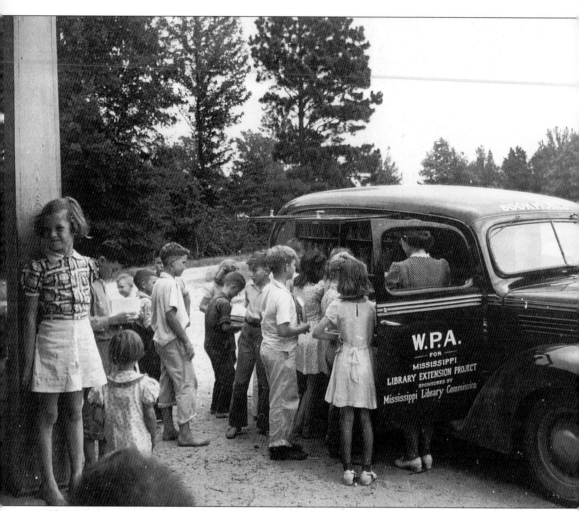

The WPA cooperated with the Mississippi Library Commission to fund bookmobiles that traveled through rural areas of the state. This librarian delivered books to children in Hinds County. By 1938, the WPA had established 5,800 traveling libraries across the United States. (Mississippi Department of Archives and History.)

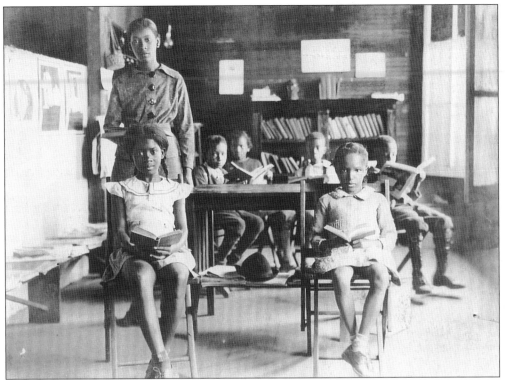

The Library Project also developed new libraries and reading rooms in Hinds County. These students and a librarian were photographed by the WPA in November 1936. (Mississippi Department of Archives and History.)

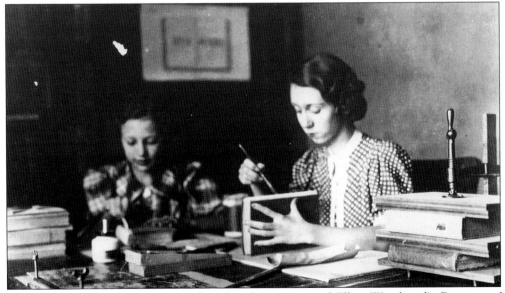

The WPA bookbinding project fell under the auspices of Ellen Woodward's Division of Women's and Professional Programs. The bookbinding project provided jobs for unskilled women and served local libraries and school systems that could not afford professional binding. These women bound books in Jackson. (Mississippi Department of Archives and History.)

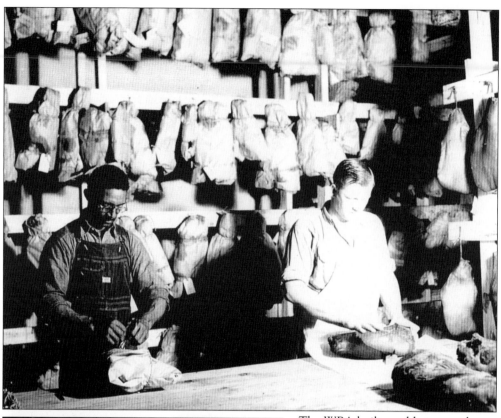

The WPA built a cold storage plant in Brandon, Mississippi for use by farmers in the community. These workers wrapped hams in preparation for cold storage. The building was demolished in 1998; it had been used as a farmers cooperative. (National Archives.)

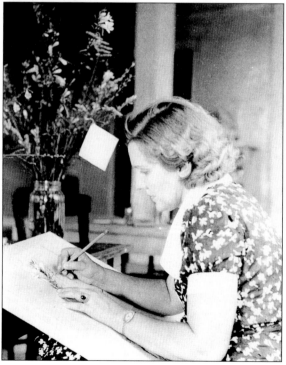

This artist worked for the WPA on a plant and animal survey project. She helped to illustrate a series of nature books. The WPA worked with the Bird and Fish Commission, presently the Wildlife, Fisheries, and Parks Department. (National Archives.)

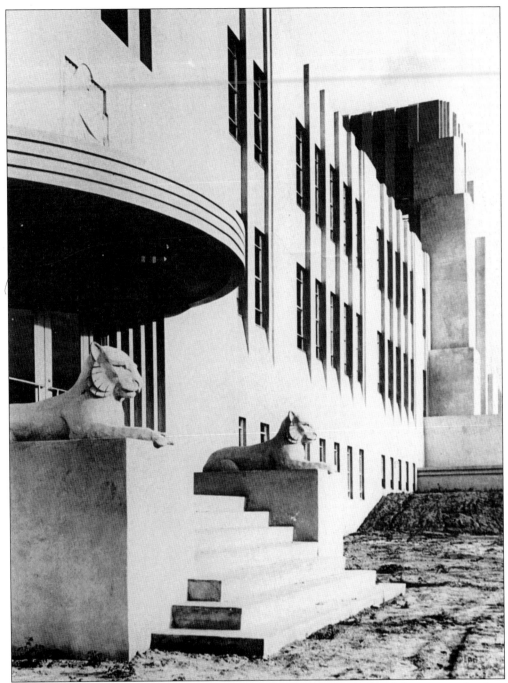

Jackson architects N.W. Overstreet and A. Hays Town were honored by *Life* magazine for their design of Bailey Junior High School. The Federal Emergency Relief Administration (FERA) provided funding and labor to build Bailey. FERA was one of several relief programs created in the famous first 100 days of Franklin Roosevelt's presidency. FERA furnished about $1 billion to states, cities, and charitable organizations during its two-year existence. (Mississippi State University Special Collections.)

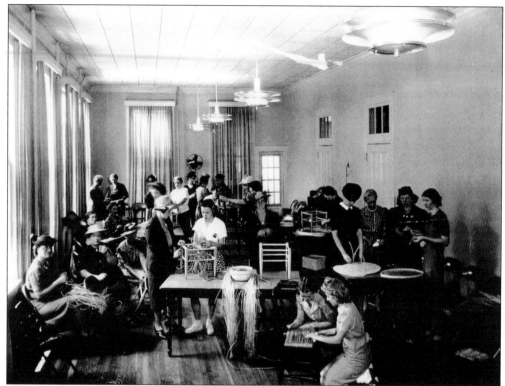

Local and state agencies also coordinated work projects; this workshop was conducted by Mary Agnes Gordon, an extension service specialist. In 1940 women from around Hinds County met at the YWCA building on North State Street for training in weaving and repairing chairs and stools. (Courtesy of Janice C. Jones.)

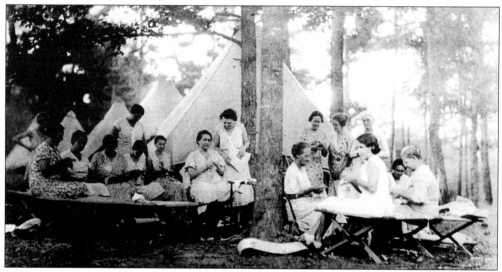

The Mississippi State University Extension Service sponsored a Home Demonstration Club camp for women from Hinds County and Rankin County. The camp was held at the American Legion reservation in August 1937. The women are pictured making gloves. (Courtesy of Janice C. Jones.)

# *Six*
# THE HOME FRONT

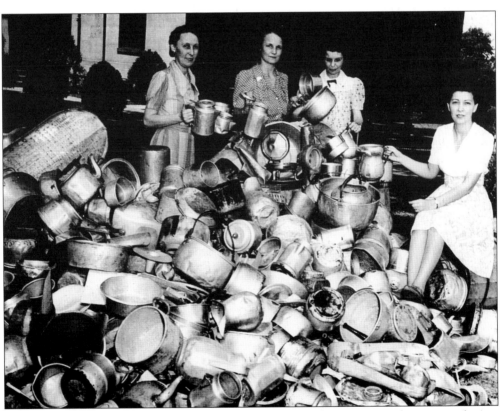

Jackson's WW II "Salvage for Victory" campaign encouraged women's involvement in the war effort. The city held a parade in May 1942 highlighting the scrap collection campaign. Suggestions for contributions included old water tanks, tricycles, golf clubs, cooking utensils, and gardening tools. Local stores reported that all steel and brass articles, including hairpins and sewing needles, would not be available for the duration of the war. (LeFleur's Bluff Heritage Foundation.)

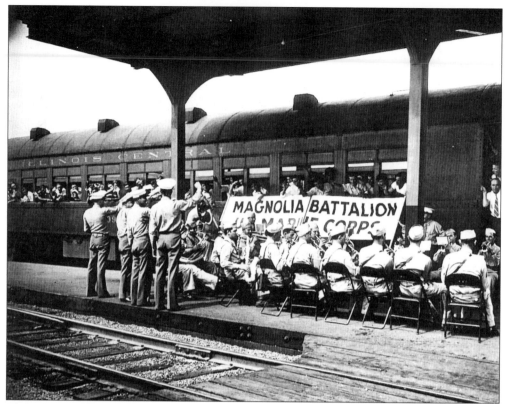

The "Magnolia Battalion" of the Marine Corps was composed entirely of Mississippians. The recruits left Jackson on July 4, 1942, from the Illinois Central Railroad depot; they trained in San Diego and served in the Pacific. A grand parade from the Old Capitol to the train station marked the occasion. (Mississippi Department of Archives and History.)

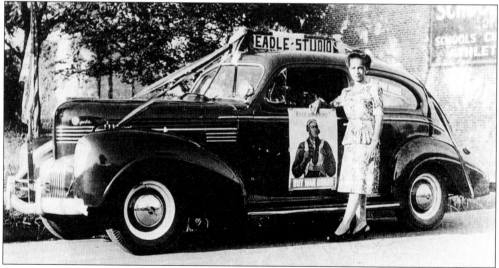

Mrs. Juanita Davis Beadle, wife of photographer Richard Henry Beadle, stood beside the car used in the family's photography business. The poster on the car promoted the sale of WW II war bonds. (Family of Richard Henry Beadle.)

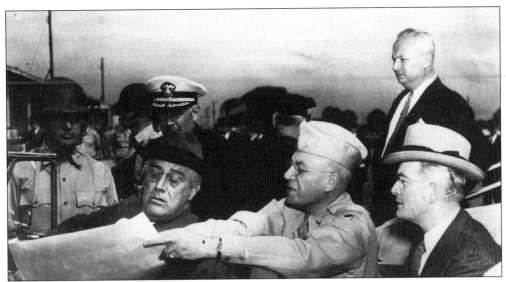

In 1943 Franklin D. Roosevelt came to Mississippi to inspect troops and defense preparations at Camp Shelby, located near Hattiesburg, Mississippi. Roosevelt often called Governor Paul B. Johnson Sr. late at night to discuss the war. On this occasion, Roosevelt told Johnson to keep the inspection trip a secret from his advisors and family members. (Mississippi Department of Archives and History.)

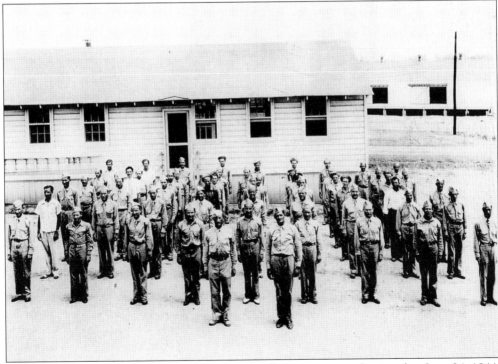

Class 44-F of the Jackson Army Air Base stood in formation on graduation day, June 24, 1944. One of the 163 buildings that made up the Air Base is shown behind the group. Located in west Jackson on the site of the first Jackson Municipal Airport, construction of the Air Base cost over $5 million. (Mississippi Department of Archives and History.)

The new Jackson Air Base at Hawkins Field became the headquarters of the Royal Netherlands Military Flying School in 1941. The Netherlands fell to the Nazis in the spring of 1940, and Dutch flyers occupied the air base until 1943, when the United States Army Air Corps took over the facility. The city of Jackson provided burial plots at Cedar Lawn Cemetery for Dutch pilots killed during training exercises. (Mississippi Department of Archives and History.)

During WW II, the U.S. Corps of Engineers built a prisoner-of-war camp near the town of Clinton. The camp held about 3,000 German prisoners, including several important German generals. Former prisoner Otto W. Dopheide revisited the camp in 1982; he remembered General "Papa" Ramke, who "escaped the camp in 1945 in full uniform, hitched a ride to Jackson, wrote a letter of complaint to the U.S. Senate and returned to the camp undetected." (Mississippi Department of Archives and History.)

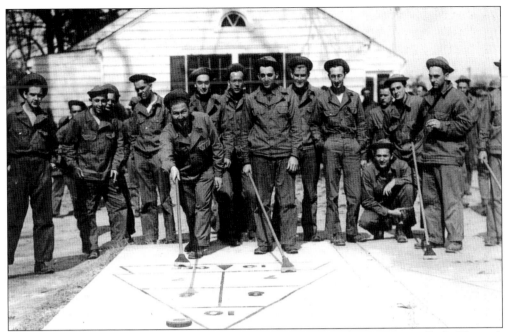

Servicemen from the nearby Jackson Army Air Base often relaxed at Livingston Park. The park charged 12¢ for swimming and 50¢ for golf. The WPA published a weekly entertainment newsletter for soldiers stationed in Jackson. Community support for servicemen was widespread; churches and civic organizations planned dances and recreational activities. (LeFleur's Bluff Heritage Foundation.)

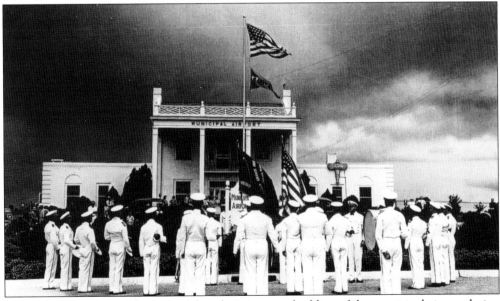

A Navy band performed in front of the administration building of the municipal airport during WW II. The Army Air Base opened its airfield to the Navy from December 1943 until the end of the war; over 16,000 Navy planes landed in Jackson. The Naval Air Transport Service ferried bombers, fighters, and torpedo planes from the east coast to the west using Jackson for layovers. (Mississippi Department of Archives and History.)

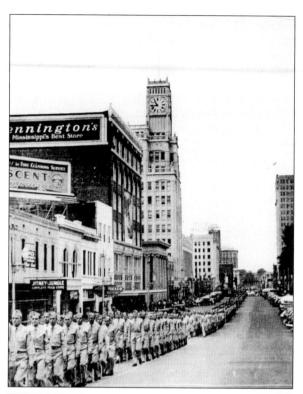

Hundreds of soldiers from the Jackson Army Air Base marched up Capitol Street during this WW II parade. Parades provided an important form of entertainment and a way to exhibit patriotism during the late 1800s and the first half of the 20th century. (Mississippi Department of Archives and History.)

This military parade honored local soldiers who died fighting in WW II. (Mississippi Department of Archives and History.)

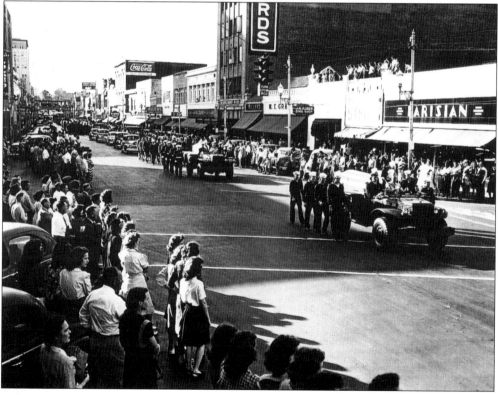

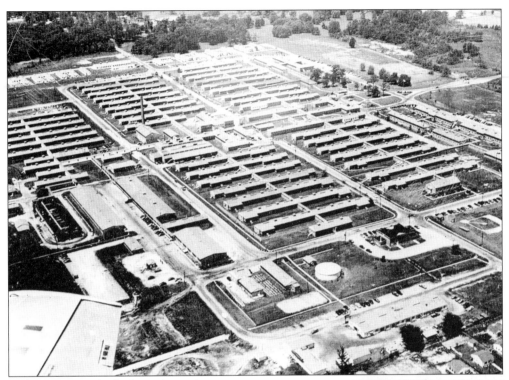

Built in 1943 at the Jackson Army Air Base, Foster General Hospital cared for soldiers wounded in WW II. In 1946, the Department of Veterans Affairs took over the hospital, which was made up of 112 buildings on a 136-acre site. Doctors rode large tricycles up and down the long hallways during their daily rounds. The current facility opened in January 1962 on Woodrow Wilson Boulevard. On Veterans Day 1996, the hospital was named for Congressman G. V. "Sonny" Montgomery, who championed veterans' causes during his 30 years of congressional service. (Courtesy of G.V. "Sonny" Montgomery Veterans Administration Medical Center.)

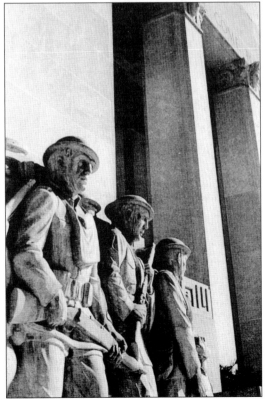

Mississippi's War Memorial Building opened in 1940, next to the Old Capitol. The American flag at the center of the Memorial flies at half staff. (National Archives.)

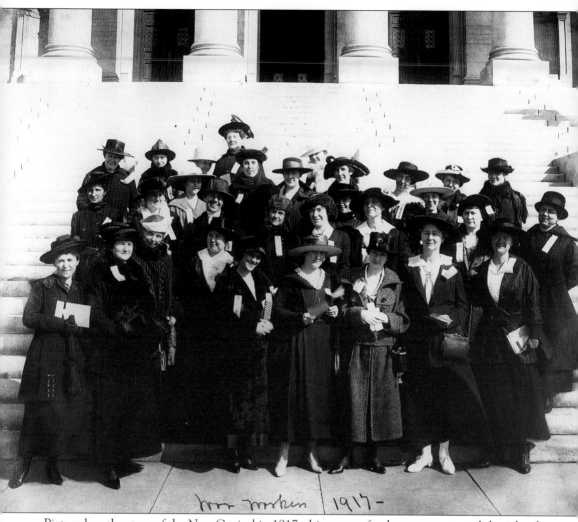

*war workers 1917 -*

Pictured on the steps of the New Capitol in 1917, this group of volunteers promoted the sale of WW I Liberty Bonds. Many women's clubs in Jackson were heavily involved in the war bond effort during WW I and WW II. (Mississippi Department of Archives and History.)

# *Seven*

# CLASSROOMS

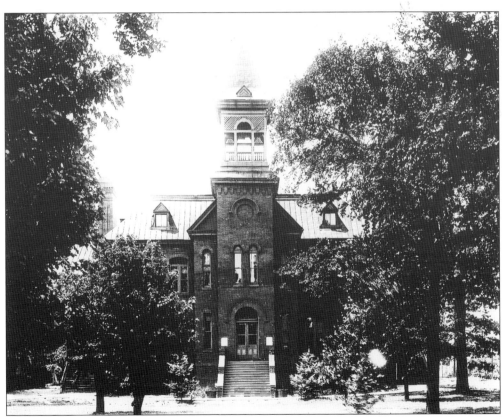

Jackson's first graded public school opened in 1888 on North West Street. That year the school welcomed about 400 students in ten grades. In 1911, renovations were made, an annex was built, and the building became Central High School. The third building opened in 1925, and it incorporated parts of the first two schools. (Mississippi Department of Archives and History.)

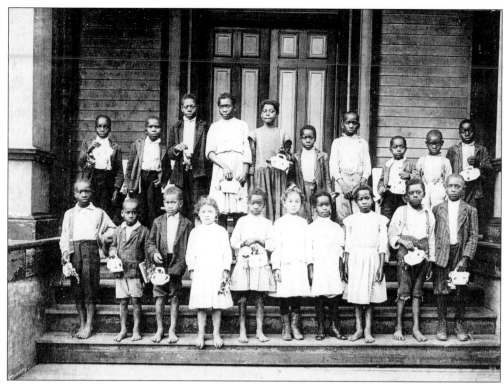

Daniel Hand Elementary School operated on the Tougaloo College campus from about 1900 until the mid-1950s. This school picture probably dates to 1911. (Tougaloo College Archives.)

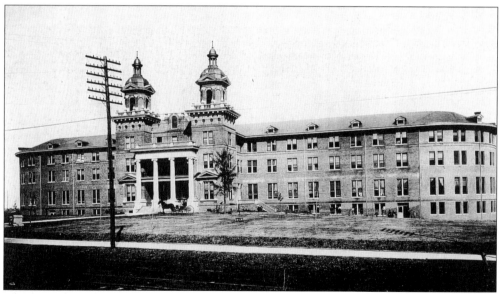

The state's second Deaf and Dumb Institute opened in 1904 on West Capitol Street. Mississippi had the first state-supported school for the deaf in the nation; it opened in 1854. The Mississippi School for the Deaf is presently located on Eastover Drive in northeast Jackson. (Mississippi Department of Archives and History.)

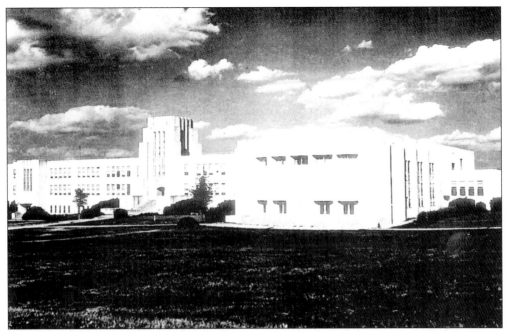

Edward L. Bailey Junior High School was named for a former city superintendent of schools. Completed in 1937, the building cost $87,000 and continues to operate as a magnet school in the Jackson Public School system. (Mississippi Department of Archives and History.)

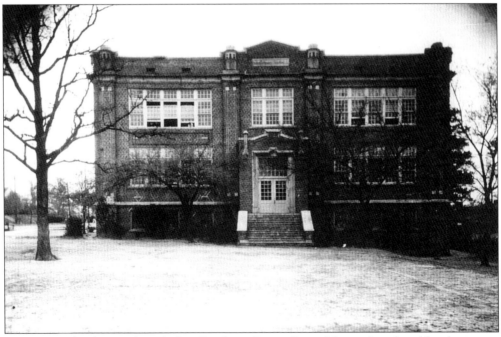

J.L. Power School opened in 1916 on Pinehurst Street. One of the city's early public elementary schools, Power School, among others, took students in lower grades who previously would have attended Central School. (Mississippi Department of Archives and History.)

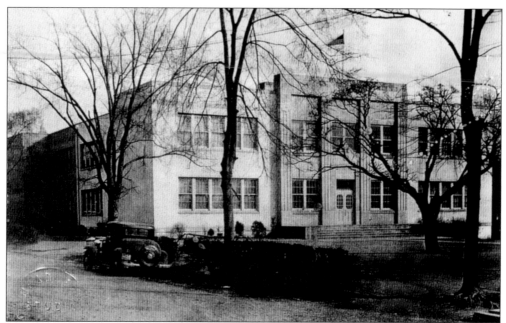

Smith Robertson School opened in the late 1890s. Named for an African American who served as a city alderman from 1893 to 1899, the school was the first public school in Jackson for black children. Smith Robertson's influence prompted city leaders to fund the school; he also owned a barber shop located near Spengler's Hotel. (Mississippi Department of Archives and History.)

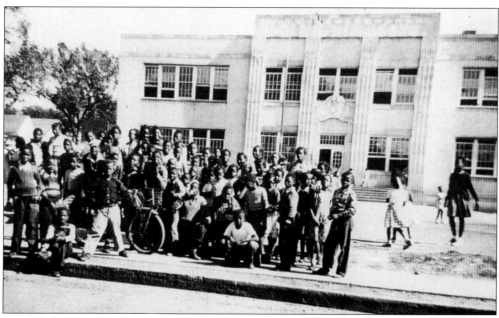

Smith Robertson School closed in 1971. The city planned to demolish the school in 1977, but concerned citizens campaigned to save it. The building now houses the Smith Robertson Museum and Cultural Center. The museum includes exhibits portraying the life, history, and culture of African Americans in Mississippi. (Smith Robertson Museum and Cultural Center.)

This band contest featured local schools parading down Capitol Street. Probably taken in the late 1940s or early 1950s, this photograph highlights the performance of a band from the neighboring town of Madison. (Mississippi Department of Archives and History.)

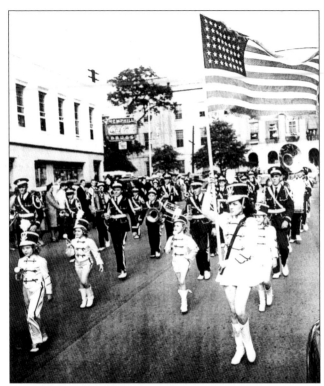

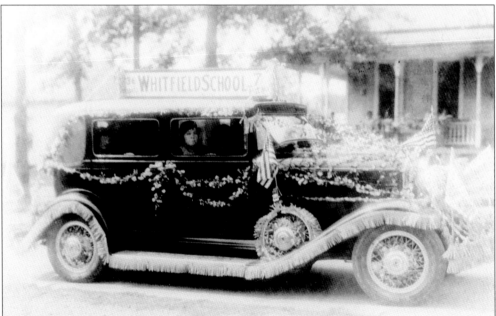

Whitfield Elementary School opened in September 1927 on Claiborne Street in west Jackson. Whitfield School, named for Governor Henry Lewis Whitfield, had only six classrooms that opened into one main hall. The school had no library; books were placed on shelves in the hall. Whitfield School participated in this 1932 parade on Capitol Street. The building was demolished in the 1960s. (LeFleur's Bluff Heritage Foundation.)

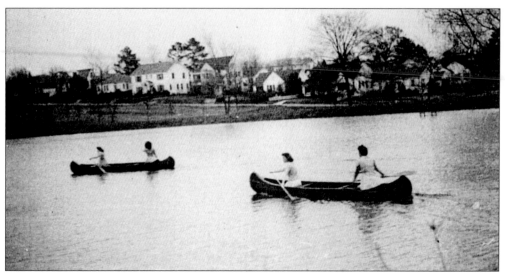

Belhaven College opened in 1894 as a private school for young women; the school was first housed in a mansion of the same name. Belhaven moved to its current location at Pinehurst Street and Peachtree Street in 1911 and is affiliated with the Presbyterian Church. In 1998, the college drained Belhaven lake (shown here in 1940) in order to construct a new women's residence hall; the lake will be rebuilt in a much smaller size. (Courtesy of Mary Jane Hall.)

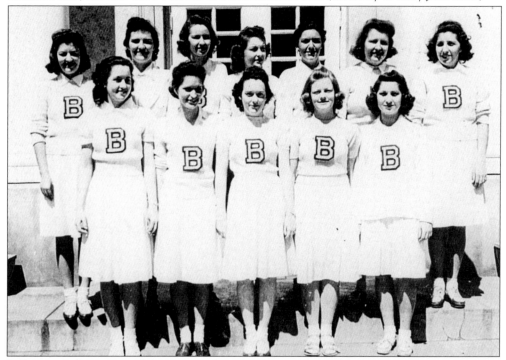

Belhaven College's "B" Club recognized outstanding student athletes. This photograph shows 1942 "B" club members. From left to right are: (front row) Hilda Coen, Ruth Ehrenfeld, Lois Terry, Mary Jane Hall, and Dorothy Turner; (back row) "Daisy" Lane, Miss Alexander (physical education instructor), Betty McMullan, Virginia Gooch, Miss Lane, Ruth Campbell, and Zell Martin. (Courtesy of Mary Jane Hall.)

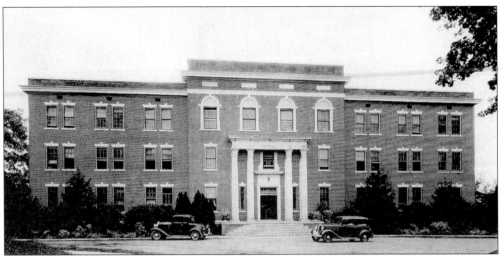

Mississippi College, located in Clinton, is the oldest college in the state. Chartered by the state legislature in 1826, Mississippi College has been operated by the Mississippi Baptist Convention since 1850. Crestman Hall, photographed in the 1930s, still serves as a women's dormitory. Crestman was built with bricks salvaged from the demolition of First Baptist Church's Capitol Street building. (Mississippi Department of Archives and History.)

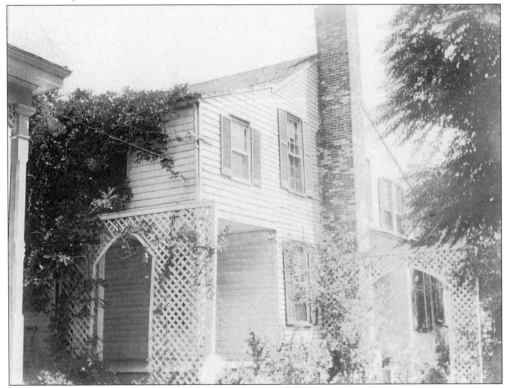

Hillman College, founded in 1853 as Central Female Institute, was also located in the nearby town of Clinton. Clinton was one of the contenders for the position of state capital during Jackson's difficult early years. Hillman College merged with Mississippi College during the mid-20th century. (Mississippi Department of Archives and History.)

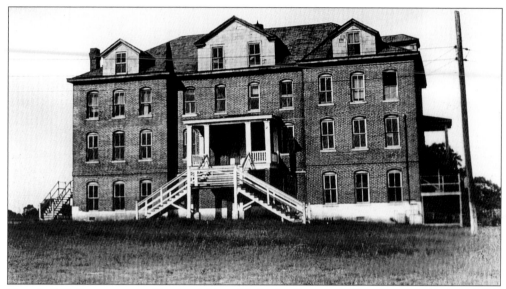

Campbell College, supported by the African Methodist Episcopal Church, opened in Vicksburg around 1885 and moved to Jackson in 1898. This was the college's administration building. Located in west Jackson on Lynch Street, Campbell became a part of its neighbor, Jackson State College, during the 1950s. (Mississippi Department of Archives and History.)

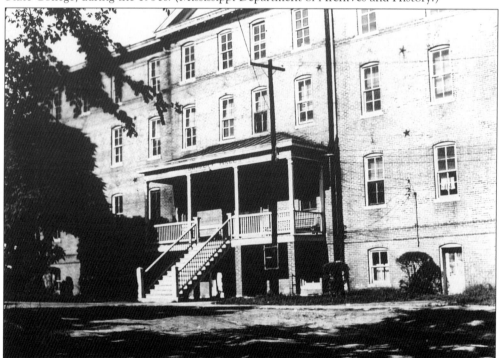

In 1877, Dr. Charles Ayer founded a training school for African-American teachers in Natchez, Mississippi. The school moved to Jackson in the 1880s and became Jackson College. This photograph shows Barrett Hall of Jackson College. The school was transferred to the state in 1940. Today Jackson State University has over 6,000 students. (Mississippi Department of Archives and History.)

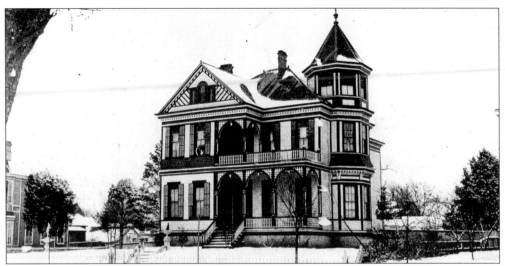

In 1888, Reuben Webster Millsaps built a Queen Anne-style house at 628 North State Street. Millsaps, a prominent business leader and philanthropist, donated land and money totaling $550,000 to build and support Millsaps College. After Millsaps died in 1916, the house passed to his nephew Webster Millsaps Buie; major alterations changed the appearance of the exterior of the house in 1928. Today descendants of the Millsaps family operate Millsaps-Buie House as a bed-and-breakfast. (Mississippi Department of Archives and History.)

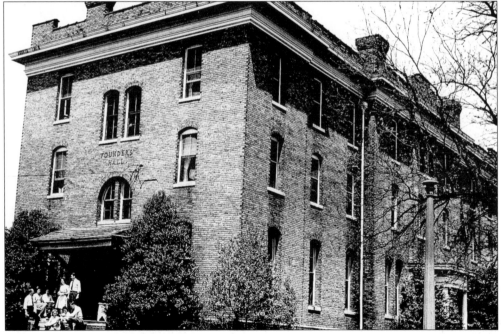

Millsaps College held its first classes in September 1892. In 1902, Jackson College sold its adjoining property on North State Street to Millsaps for $40,000. The early college had a law school and a preparatory school. Founders Hall, pictured during the 1930s, was built by Jackson College in 1885 and served Millsaps College until it was torn down in 1973. At different times, Founders Hall housed a cafeteria, a dormitory, classrooms, and faculty offices. (Mississippi Department of Archives and History.)

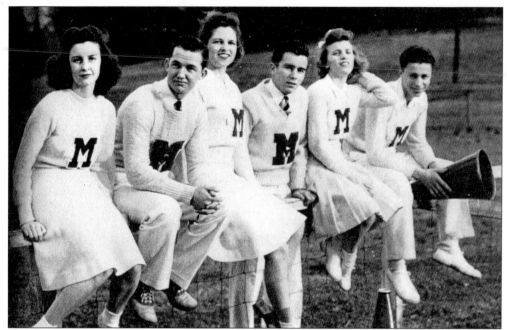

During WW II, enrollment at Millsaps College peaked at 873 students. This number included students taking part in the Navy training program known as V-12. This photograph shows the 1942 Millsaps College cheerleading squad. (Millsaps College Archives.)

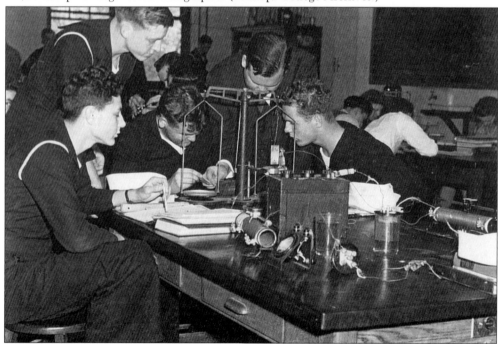

From 1943 to 1945, men from the United States Navy attended classes at Millsaps. The V-12 program prepared officer candidates for wartime service while allowing them to receive a college education; 488 men from 26 states trained at Millsaps in 1943. Mississippi College also employed this program. (Millsaps College Archives.)

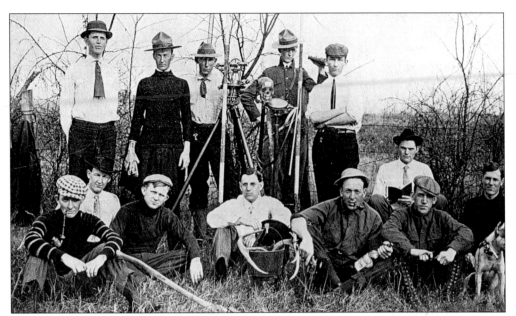

The 1911 course catalogue for Millsaps College included a surveying class. The second man from the right on the front row is T.W. Lewis, father of Millsaps Professor Emeritus, Dr. T.W. Lewis. (Millsaps College Archives.)

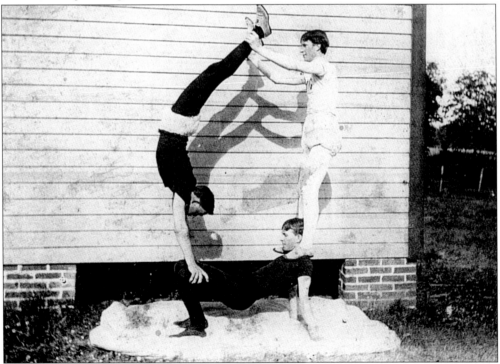

Two members of the Millsaps College gymnastics team, Wharton Green (right) and E.H. Galloway (bottom), joined their instructor, J.P. Lewis, in a stunt. The photograph, dated 1897, was taken in front of the gymnasium which was located behind Old Main Hall. (Millsaps College Archives.)

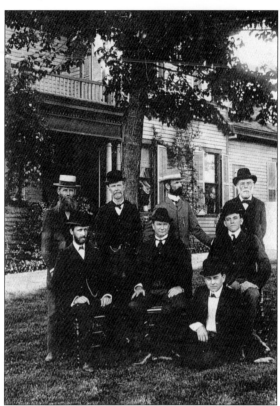

This photograph, dated 1902, is probably the earliest taken of the Millsaps College faculty. Members included, from left to right: (seated) Dr. Anthony Moultree Muckenfuss (science), President William B. Murrah, Dr. Burt Edward Young (romance languages), and Professor David Horace Bishop (English); (standing) Dr. James Adolphus Moore (mathematics), Dr. George W. Huddleston (ancient languages), Dr. George Crawford (ancient languages), and Professor Robert F. Ricketts (mathematics). (Millsaps College Archives.)

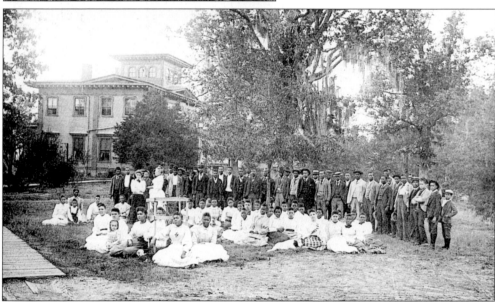

The Tougaloo College class of 1903 gathered on the lawn of the college for a graduation picture. In 1869 the American Missionary Association bought 500 acres of land and founded Tougaloo College. The oldest building on Tougaloo's campus, the Mansion, also known as the Robert O. Wilder Building, was included in the original land purchase. The Mansion can be seen behind the students. (Tougaloo College Archives.)

# *Eight*
# HELP WANTED

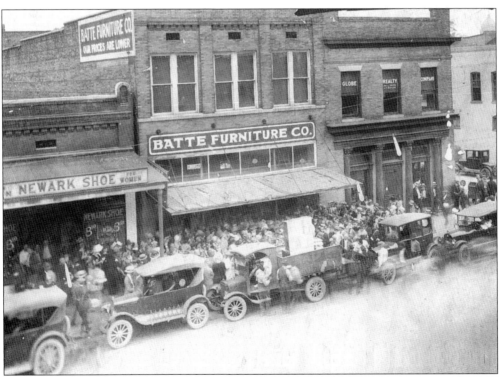

Batte Furniture Company was founded in 1883 by Edwin A. Batte; the store operated out of three different locations on Capitol Street until 1969. Batte was one of the first stores in Jackson to sell the Edison Phonograph. A fourth-generation family business and one of the oldest businesses in Jackson, Batte Furniture and Interiors is now located at 1010 East Northside Drive. (Courtesy of John C. Batte III.)

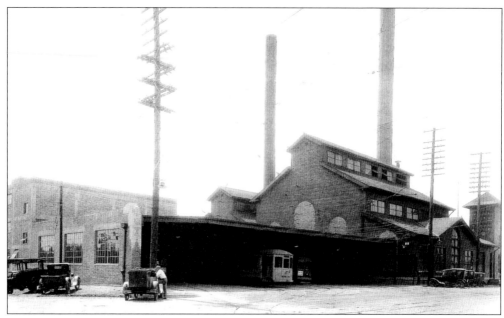

The Mississippi Power and Light Company repaired and serviced electric streetcars at this "car barn" on Commerce Street near the state fairgrounds. The street car shop is pictured in 1929 with the power plant in the background. (LeFleur's Bluff Heritage Foundation.)

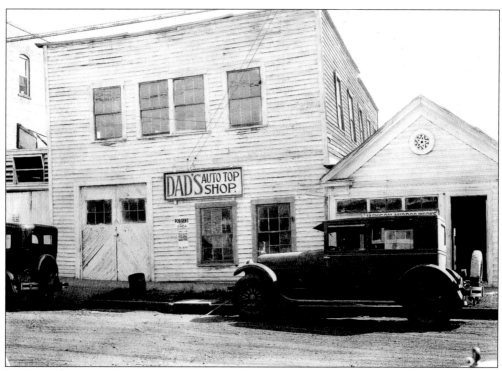

By 1927, the YMCA owned this frame building on West Street near Pearl Street. With the advent of hard-topped automobiles, Dad's Auto Top Shop fell on hard times. (LeFleur's Bluff Heritage Foundation.)

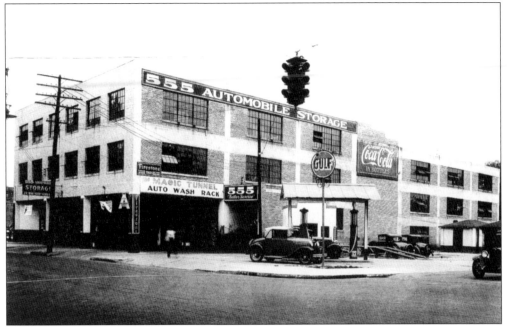

Located on Pearl Street at the intersection of Lamar, 555 Automobile Storage provided all-inclusive auto service. Their advertisements claimed "555 has more satisfied customers than any other station in Mississippi. 555 service is 'Satisfaction Service.'" The photograph, by Hiatt Studio, is dated May 1932. (LeFleur's Bluff Heritage Foundation.)

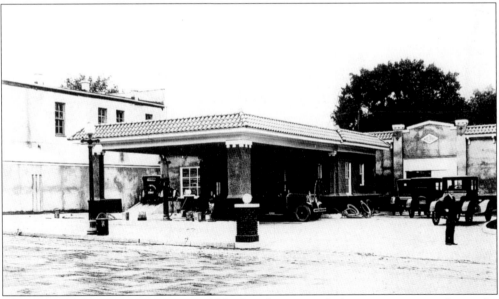

This type of full-service gas station could be found on many Jackson street corners during the first half of the 20th century. Capitol and State Streets had full-service stations. By the early 1920s, Jackson had become heavily populated with automobiles. At the inaugural parade for Governor Russell, one newspaper reported that the governor's staff would "occupy automobiles" and claimed "it is doubtful if 43 real saddle horses could be mustered in the city of Jackson." (Mississippi Department of Archives and History.)

Hederman Brothers, another fourth generation business, opened in 1898 over a small laundry in Jackson. The two brothers purchased the small job printing division of *The Clarion-Ledger* that year. In 1902, the new printing business moved next door to the newspaper on Capitol Street. One of the South's leading printing companies, Hederman Brothers is now based in Ridgeland, Mississippi. (Courtesy of Hederman Brothers.)

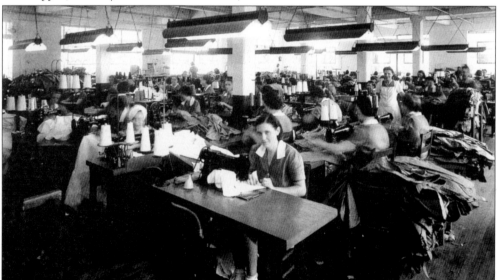

The N and W Overall Company opened its factory on South President at Silas Brown Street in 1928. N and W employed 470 people and produced work clothing. Dickies Manufacturing owned this building for several years; the former factory now houses an art studio, a frame shop, and apartments. (LeFleur's Bluff Heritage Foundation.)

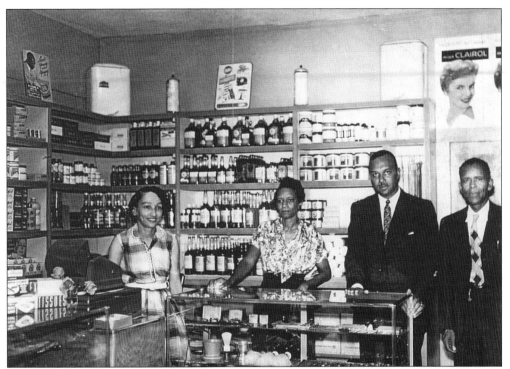

Conic Beauty and Barber Supply operated from 1950 to 1975 at 615 North Farish Street. From left to right are: Doris V. Conic, Myrtle C. Johnson, Frank N. Conic, and Jack Johnson. Frank Conic owned a barber shop before he opened this business. (Smith Robertson Museum and Cultural Center.)

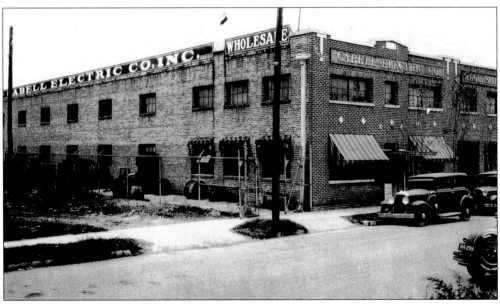

Cabell Electric Company, Inc., pictured in 1929, was Mississippi's largest distributor of electrical goods and Temple radios. The company's offices and warehouse were located on South Farish Street. (LeFleur's Bluff Heritage Foundation.)

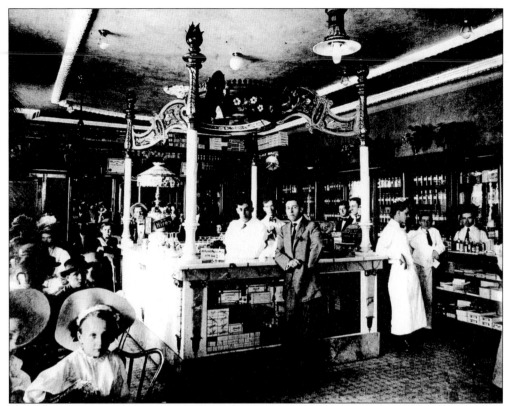

Hunter and McGee Drugstore occupied the northwest corner of Capitol and State Streets. The man wearing a business suit (center) is J. Clyde McGee, co-owner of the drugstore, which opened in 1905. (LeFleur's Bluff Heritage Foundation.)

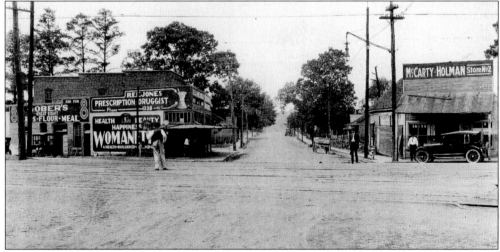

McCarty-Holman Company opened its first grocery store in 1912; the No. 2 Store was located at the corner of Porter and Gallatin. In 1917, McCarty-Holman Stores offered a pound of pure lard for 18¢ and a pound of evaporated prunes for 17¢. Jitney Jungle Stores of America, successor of McCarty-Holman Company, currently operates over 100 stores in several states and is Mississippi's largest retailer. (LeFleur's Bluff Heritage Foundation.)

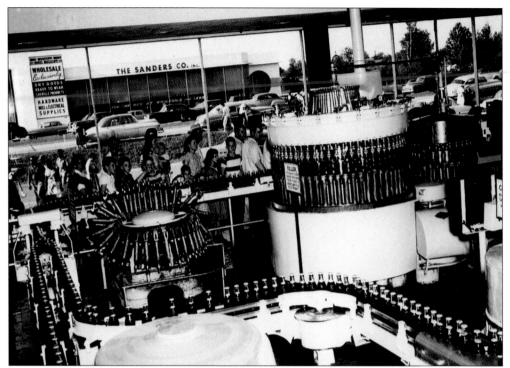

Jackson Coca-Cola Bottling Company was founded by P.L. Borden in 1903; the company moved to its present location on U.S. Highway 80 in 1949. Part of the bottling facility was open to the public for many years and was a favorite field trip for thousands of children in Jackson's schools. (Jackson Coca-Cola Bottling Co.)

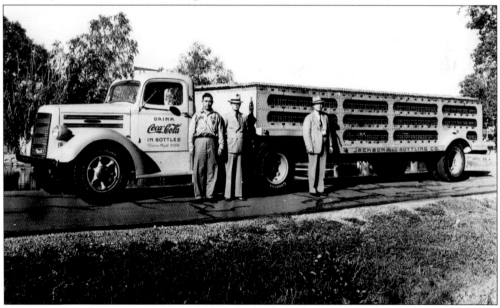

The Coca-Cola delivery truck could carry thousands of glass bottles in wooden cases to stores in Jackson and surrounding communities. The truck returned empty bottles to the plant, where they were machine-cleaned and refilled with Coke. (Jackson Coca-Cola Bottling Co.)

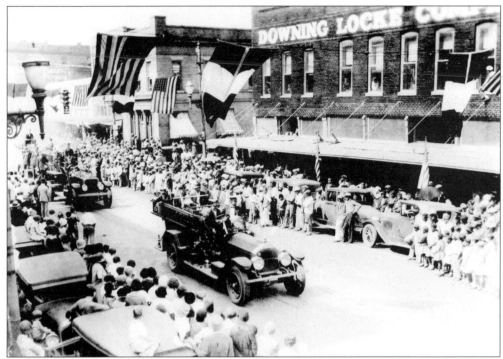

Located on Capitol Street, Downing Locke's offered a unique shopping experience. Sales clerks placed a customer's purchases and money in a wire basket and used a pull cord to send the basket on an overhead wire track to a cashier upstairs on the mezzanine level. Customers could watch baskets fly overhead while they waited. (LeFleur's Bluff Heritage Foundation.)

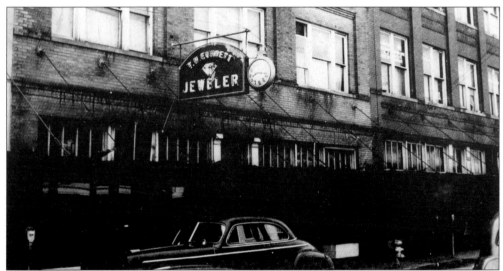

Around 1890, African Americans began to build a unique neighborhood where businesses and residences were in harmony. The Farish Street area has great historical significance as the largest economically independent black community in Mississippi. From 1890 to 1930, Jackson experienced exceptional growth; most of the buildings in the Farish Street Historic District were constructed during this period. (Mississippi Department of Archives and History.)

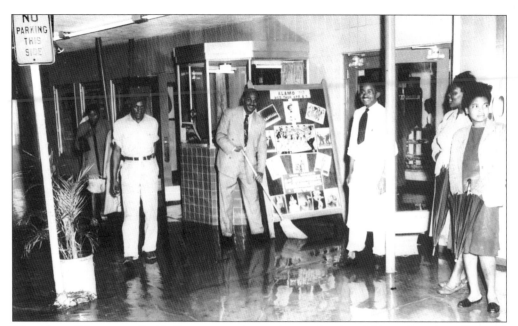

The Alamo Theater on Farish Street opened as a cinema showing African-American films and "chase westerns"; later the theater featured performing arts. Today, the theater has been restored and is part of the Farish Street Historic District. (Mississippi Department of Archives and History.)

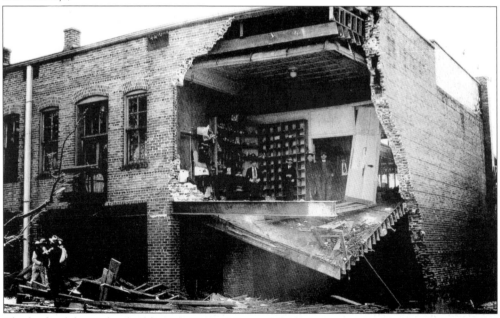

The back of the Huber building on Capitol Street fell victim to yet another Town Creek flood in April 1921. The building was particularly vulnerable to this kind of destruction because of its location; Town Creek often overflowed through the area where Lamar Street intersects Capitol. The building was condemned and destroyed to make way for Lamar Street after this flood. Joe Huber had a well-known shoe repair shop in this building. (LeFleur's Bluff Heritage Foundation.)

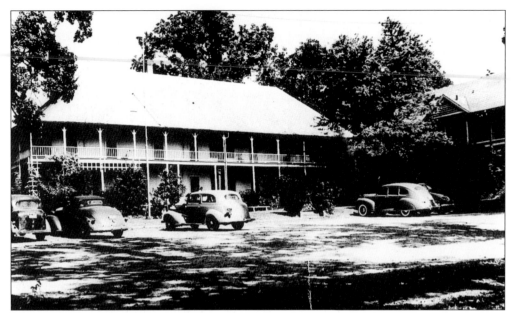

Pictured around 1940, Allison's Wells hotel was located several miles north of Jackson near the town of Canton. The hotel began as a four-room tavern on the old Natchez Trace. At the turn of the century, Jacksonians made the resort a popular retreat from town life. In 1948, the resort became an art colony, eventually housing over a hundred artists; Karl and Mildred Wolfe helped develop the colony. The hotel burned in 1963. (LeFleur's Bluff Heritage Foundation.)

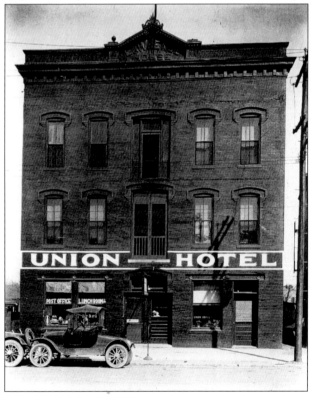

Lawrence House opened in 1880 on North Mill Street, across from the Illinois Central Railroad depot. The photograph shows the hotel in the 1920s after its name was changed to Union Hotel. This building was torn down. (Mississippi Department of Archives and History.)

The ten-story Lampton Building opened in 1928 at Pearl and West Streets. This building helped to relieve the shortage of office space in Jackson; between 1920 and 1930, the town's population had grown from 22,817 to 48,282. Mississippi Power and Light bought the building and renamed it the Electric Building. The parish house of St. Andrews appears on the far left side of the picture. (LeFleur's Bluff Heritage Foundation.)

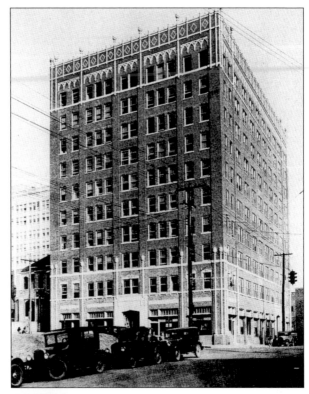

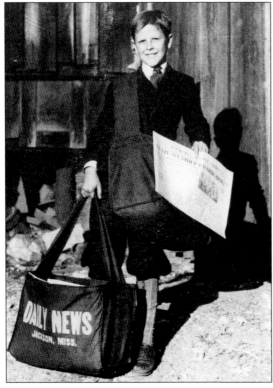

A WPA photographer captured this delivery boy who worked for the *Jackson Daily News*. The *Daily News* was probably the first newspaper in Jackson to print more local news than state, national, and foreign news. (Mississippi Department of Archives and History.)

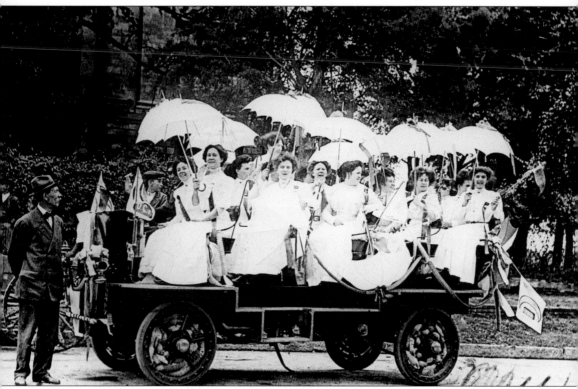

In May 1909, Jackson welcomed the United Commercial Travelers to their annual convention. This "fraternal accident insurance organization" employed "drummers" or traveling salesmen to sell insurance. Salesmen from Mississippi and Louisiana gathered in Jackson for meetings and entertainment. This group of women belonged to the Ladies Auxiliary of the United Commercial Travelers. They planned and participated in a grand parade along Capitol, State, Pearl, and President Streets. (Mississippi Department of Archives and History.)

# *Nine*

# JOURNEYS

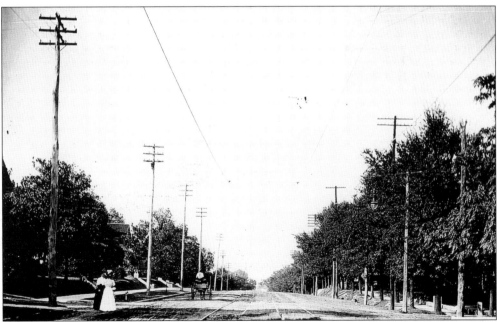

This turn-of-the-century view of North State Street highlights the tracks and overhead power lines used by electric streetcars. State Street has been a main thoroughfare throughout the city's history. (Mississippi Department of Archives and History.)

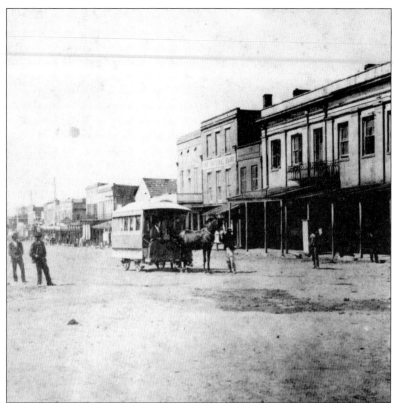

In 1871 Jackson City Railroad Company began operating mule-drawn trolleys. A trolley ride from the Edwards House to the Capitol cost 10¢; a package of 14 tickets cost $1. This trolley's route ran along State Street and passed by the Capitol in the center of town. (Mississippi Department of Archives and History.)

In 1899, electric streetcars replaced mule-drawn trolleys. This streetcar was one of the last; buses took over in 1935. Capitol Street had a double row of tracks, and was included on all city routes, adding to the street's popularity for shopping. During WW II, the city donated more than 3 million pounds of old streetcar rails to the national scrap campaign. (Mississippi Department of Archives and History.)

This E. von Seutter stereograph, probably taken in 1875, shows one of the earliest bridges or "trestles" connecting Hinds County and Rankin County over the Pearl River. This bridge was designed to accommodate horse, buggy, and foot traffic. A sign on the Hinds County side of the river warned of a $5 fine for driving faster than a walk over the trestle. (Mississippi Department of Archives and History.)

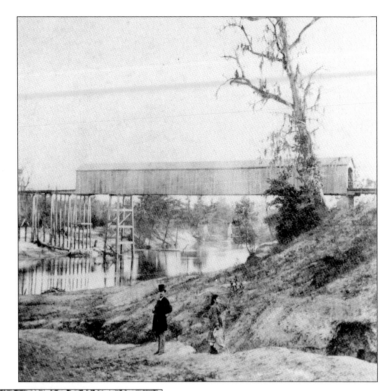

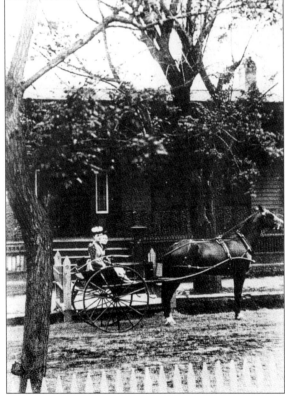

J.L. Power, a native of Ireland, moved to Jackson in 1855 and helped to found and publish a newspaper. Power held several offices in state and local government. His home, shown here, was located at 411 Amite Street; the two women are driving a runabout, also known as a two-wheel sulky. (Mississippi Department of Archives and History.)

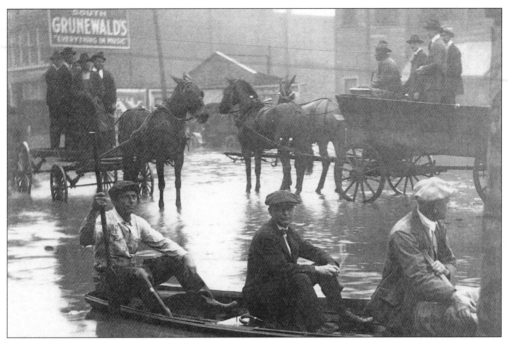

These three men found an appropriate form of transportation to handle the 1921 Town Creek flood. This photograph shows Capitol Street between West and Farish. (LeFleur's Bluff Heritage Foundation.)

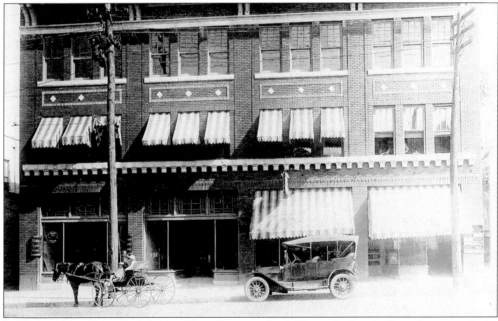

In front of his Capitol Street studio, photographer Albert Frederick Daniel captured the transition from horse and buggy to automobile. A 1906 city ordinance created a speed limit for automobiles of "twelve miles per hour in a straight run or seven miles per hour in turning corners." In 1920, top speeds were set at 15 miles per hour; speeds at intersections were limited to 7.5 miles per hour. (Mississippi Department of Archives and History.)

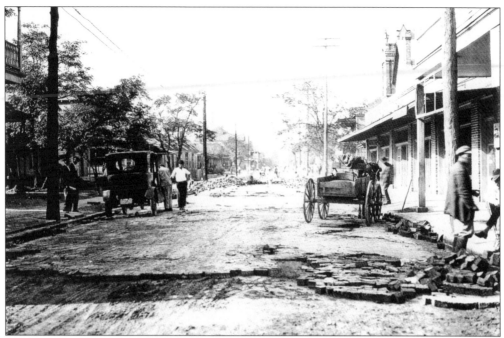

Bricks were used to pave North Farish Street in 1921. During this time, dirt roads served most of Mississippi. As the capital city, Jackson led the way in improving streets and highways. (LeFleur's Bluff Heritage Foundation.)

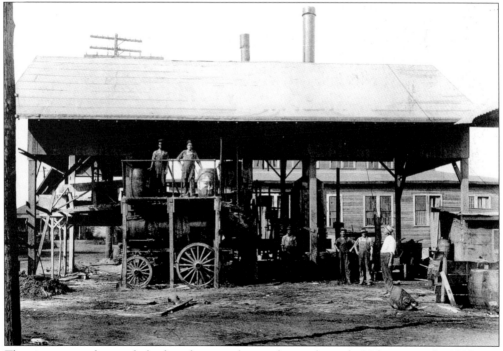

The city operated an asphalt plant for several years during the early 20th century. In 1902, city officials designated $115,000 in bonds for the city's first street paving program. (LeFleur's Bluff Heritage Foundation.)

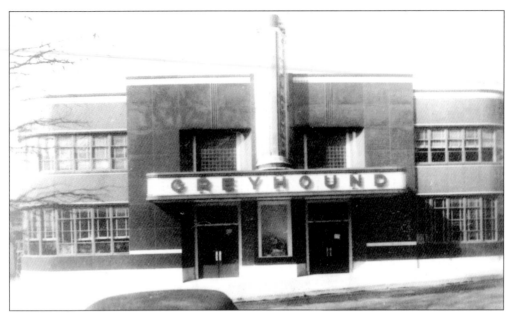

The Greyhound Bus Station, built in 1939, is an example of streamlined Art Deco architecture. After Greyhound abandoned the building in the mid-1980s, local architect Robert Parker Adams restored the station and adapted it for office space. (Mississippi Department of Archives and History.)

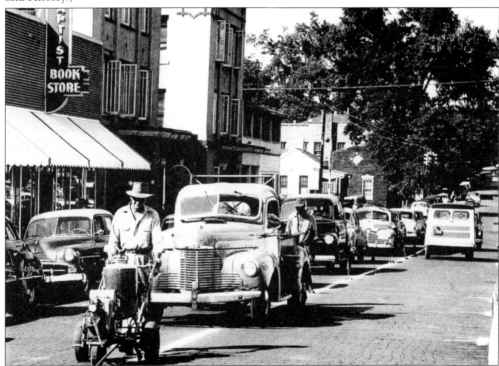

City workers painted stripes along President Street in front of the Baptist Bookstore and the Mississippi Teachers Association building which later housed the Silver Platter Restaurant and is currently the site of Frank's Restaurant. (LeFleur's Bluff Heritage Foundation.)

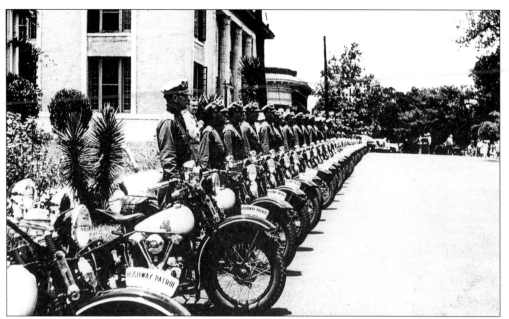

The Mississippi Highway Patrol began in 1938; patrolmen were trained at Camp Shelby near Hattiesburg and rode in a convoy to Jackson for an official parade. The Highway Patrol started with only three automobiles, and officers relied on Harley-Davidson motorcycles to patrol the entire state. (Mississippi Department of Archives and History.)

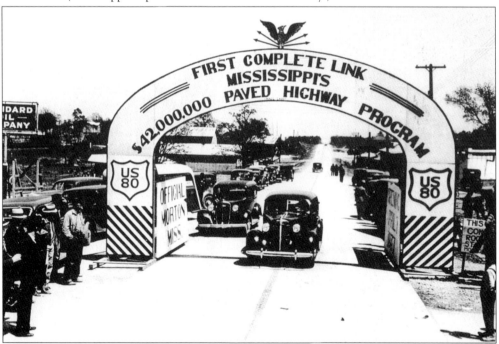

In 1937, Governor Hugh White officially opened U.S. Highway 80, the first paved highway to link one side of the state with the other. The paving of Highway 80 through Hinds County was completed in 1930. In his 1936 inaugural speech, White declared, "My sole desire is to see that we are gotten out of the mud, dust, and gravel as quickly as possible." (National Archives.)

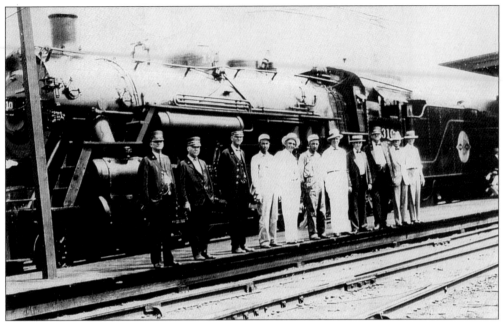

Until 1925, railroad tracks crossed Capitol Street at street level, causing massive traffic jams and splitting the city in half. Passengers on the first train to cross the new elevated railroad tracks included Mayor Walter Scott and Commissioners R.M. Taylor and A.F. Hawkins. Jackson also acquired new land in 1925, more than doubling the city's size. (Mississippi Department of Archives and History.)

The Gulf, Mobile and Ohio Railroad Depot, located at Pearl Street behind the Old Capitol, opened in 1927; it currently houses the historic preservation division of the state archives. New Orleans & Great Northern Railroad and the Gulf, Mobile & Northern Railroad cooperated to build the depot which served the city until 1954. In 1910, the New Orleans & Great Northern was one of three railroads that considered turning the deserted Old Capitol building into a train station. (Mississippi Department of Archives and History.)

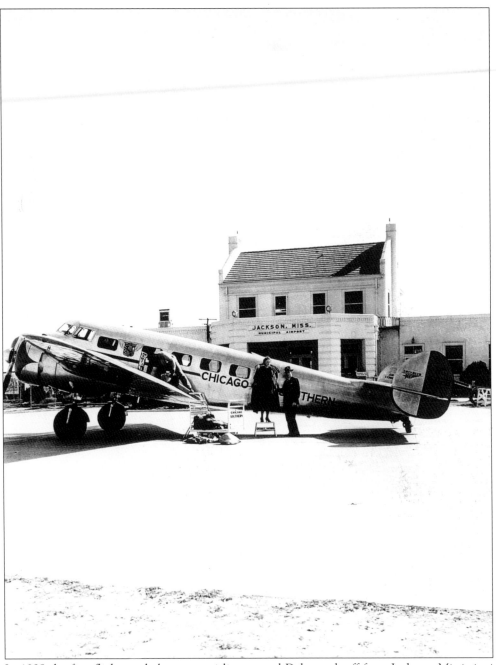

In 1929 the first flight made by a new airline named Delta took off from Jackson, Mississippi and landed in Dallas, Texas. Airline travel became popular in Jackson during the 1930s. Delta Airlines and its early competitor Chicago and Southern Airlines operated several flights daily out of Jackson Municipal Airport. (Mississippi Department of Archives and History.)

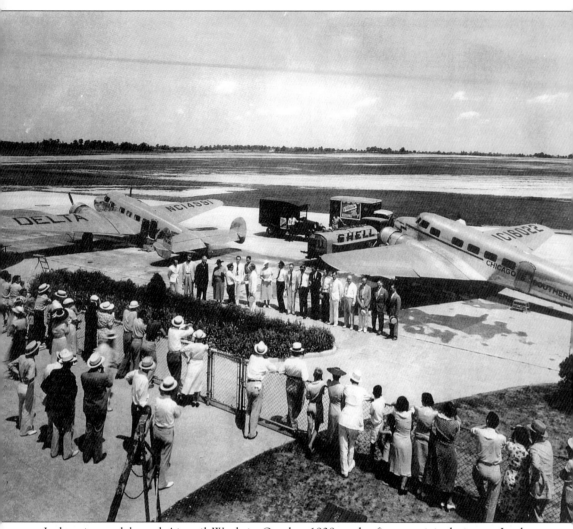

Jacksonians celebrated Airmail Week in October 1938 at the first municipal airport. In the center of the photo, City Commissioner A.F. Hawkins congratulates the postmaster. The city commission officially named the airport Hawkins Field in 1941. The city moved its main airport to Rankin County on July 8, 1963. (LeFleur's Bluff Heritage Foundation.)

## *Ten*
# BEHIND THE CAMERA

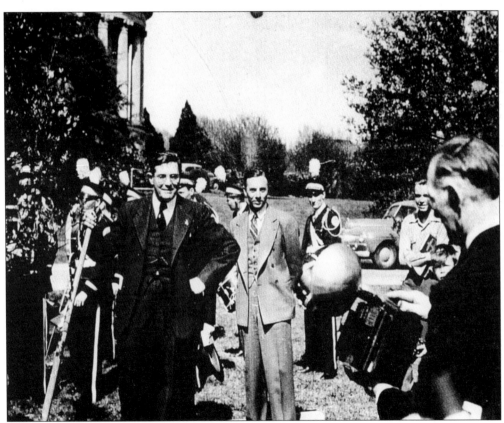

Governor Tom Bailey and State Forester Albert Legett planted an oak tree at the New Capitol during the mid-1940s; Central High School's band waited in the background. At right, holding his camera is Harry Ray Hiatt, one of Jackson's premier photographers. Hiatt came to Jackson in 1925 from Oklahoma and lived here until his death. (Mississippi Department of Archives and History.)

Elisaeus von Seutter sat for a photograph made by his daughter-in-law Gerty in the garden of his home in Jackson. After immigrating to America from Bavaria in the 1860s, von Seutter opened a photography studio in Jackson. However, photography was not his only interest. He made watches, operated a fine jewelry store, and served as Jackson's only optician. (Mississippi Department of Archives and History.)

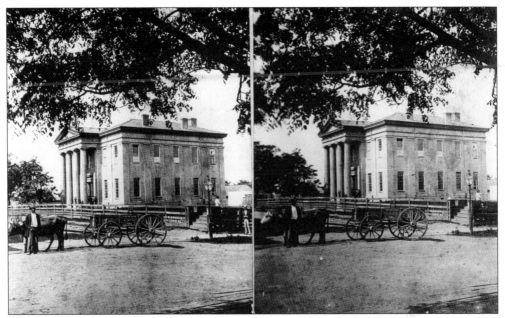

This von Seutter work is a stereograph, a pair of photographs with slightly different views of the same scene. Stereographs are viewed through a stereoscope which has a viewfinder that gives the photos a three-dimensional look. This stereograph shows Jackson's City Hall around 1875. (Mississippi Department of Archives and History.)

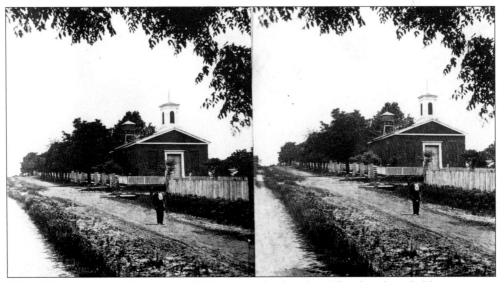

This 1870s stereograph shows one of Jackson's early churches. The church probably sat next to Town Creek. (Mississippi Department of Archives and History.)

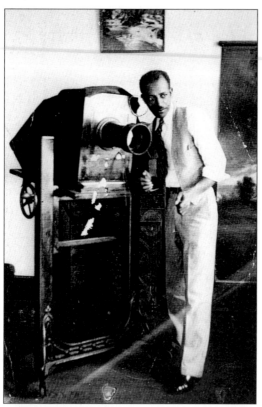

One of Jackson's leading photographers, Richard Henry Beadle, began his career in the early 1900s. Elisaeus von Seutter taught Beadle how to shoot and develop photographs. Beadle opened his studio in a tent where the Millsaps Building now stands at 201 West Capitol Street; he later moved to a studio at 119 1/2 North Farish Street. (Family of Richard Henry Beadle.)

This Beadle photograph of the Stamps Hotel, located on Fannin Road in Rankin County, was taken during the 1940s. (Mississippi Department of Archives and History.)

The Joe Catchings Playhouse, also located on Fannin Road in Rankin County, was probably in the same row of businesses as the Stamps Hotel. (Mississippi Department of Archives and History.)

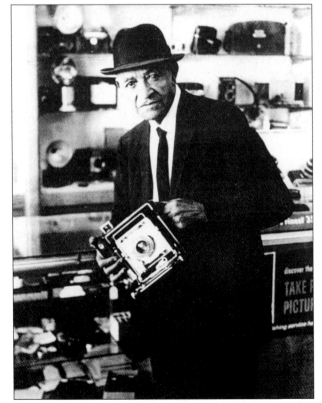

Mr. Beadle operated a highly successful studio until his death in 1971. This photograph was taken inside Standard Photo. (Family of Richard Henry Beadle.)

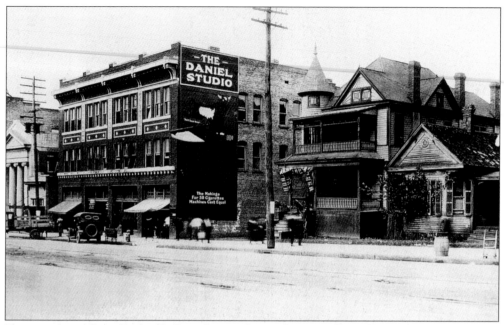

Photographer Albert Frederick Daniel owned a studio in Jackson from 1907 to 1935. The Daniel Studio was one of Mississippi's largest and most well-known photography studios. Daniel's widow, Elizabeth M. Daniel, managed the business until their son, Al Fred Daniel, took over the studio after serving as a Navy pilot during WW II. (Mississippi Department of Archives and History.)

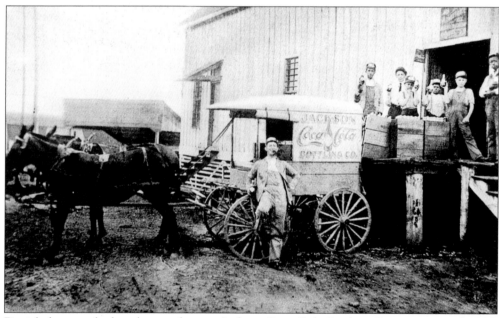

Daniel photographed workers at the new Jackson Coca-Cola Bottling Company around 1905. (LeFleur's Bluff Heritage Foundation.)

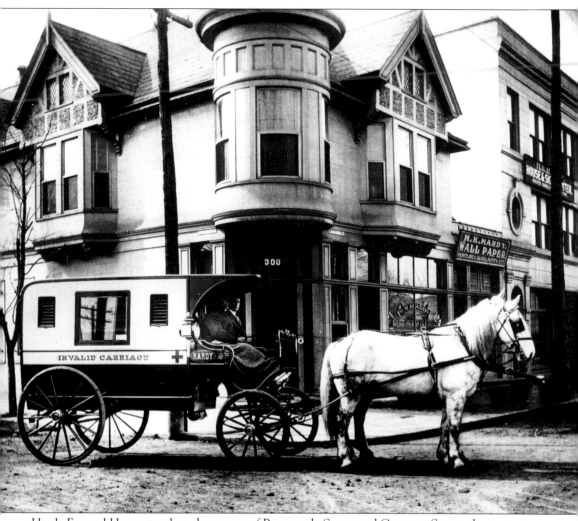

Hardy Funeral Home stood on the corner of Pascagoula Street and Congress Street, the present site of the Hinds County Courthouse. The Hardy family owned several other businesses. Daniel took this photograph in the early 1900s, before city streets were paved. The invalid carriage in the foreground was the predecessor of modern ambulances. (Mississippi Department of Archives and History.)

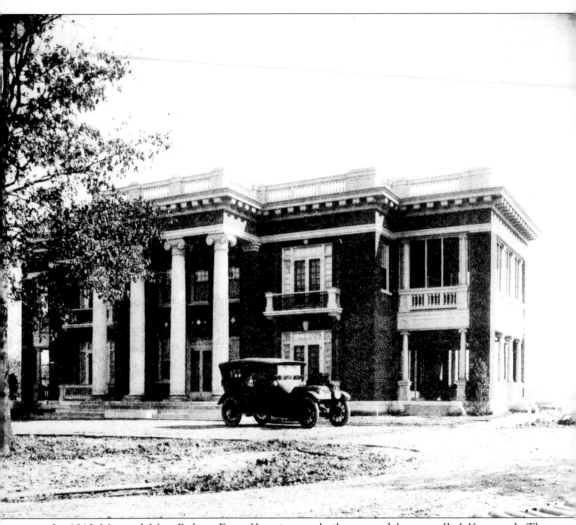

In 1912 Mr. and Mrs. Robert Estes Kennington built a grand home called Kenwood. *The Clarion-Ledger* reported that the property covered 23 acres, and the mansion was known as the "handsomest house in Mississippi." The grounds included a lake, a nine-hole golf course, greenhouses, barns, and stables. In the late 1930s, Yazoo clay cracked the foundation of the house; it was torn down, and the materials were used to construct two houses on the property at Carlisle and Kenwood in Belhaven. (Albert F. Daniel photograph, LeFleur's Bluff Heritage Foundation.)

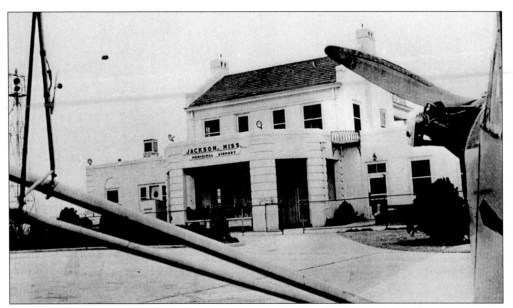

WPA photographers left behind thousands of photographs of Jackson. Throughout the country, WPA workers wrote about and photographed the history of towns and documented work relief projects. The administration building at Jackson's first municipal airport cost the city $10,000; it was built by WPA workers. (National Archives.)

WPA funds provided the first telephones for many rural areas in Mississippi; project workers also installed telephone lines. This forest ranger used a WPA-installed telephone to direct the fighting of a forest fire. (National Archives.)

Harry Hiatt took this photograph from the roof garden of the Robert E. Lee Hotel. On October 26, 1930, the Robert E. Lee Hotel opened on Lamar Street. In an interview at age 83, Hiatt discussed some of his experiences during the early days of his photography career. He recalled setting fire to hotel drapes with his flash powder and spending half a day developing each print

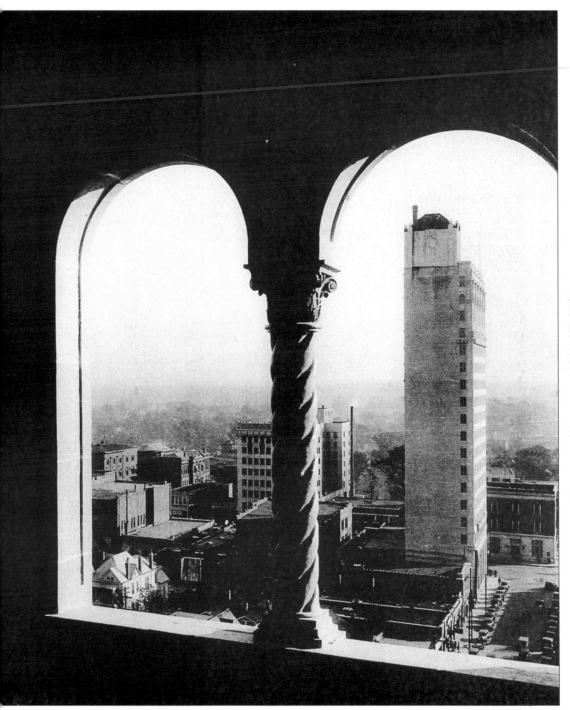

he made. During WW II, Hiatt took pictures of soldiers at the Jackson Air Base and sent the prints to the soldiers' families for any payment they could afford. The man in this photograph is probably Harry Hiatt. He also included one of his cameras in this distinctive view of Jackson's skyline as it grew into the 20th century. (LeFleur's Bluff Heritage Foundation.)

# INDEX